艺术家书系

ARTIST SERIES

米丘　观念 + 环境的艺术
MI Qiu Conceptual + Environmental Art

中国建筑工业出版社
CHINA ARCHITECTURE & BUILDING PRESS

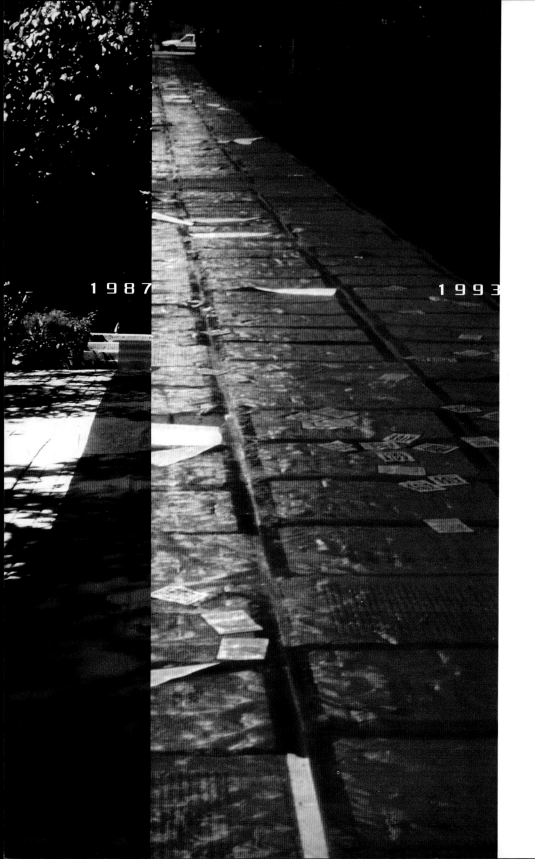
1987 1993

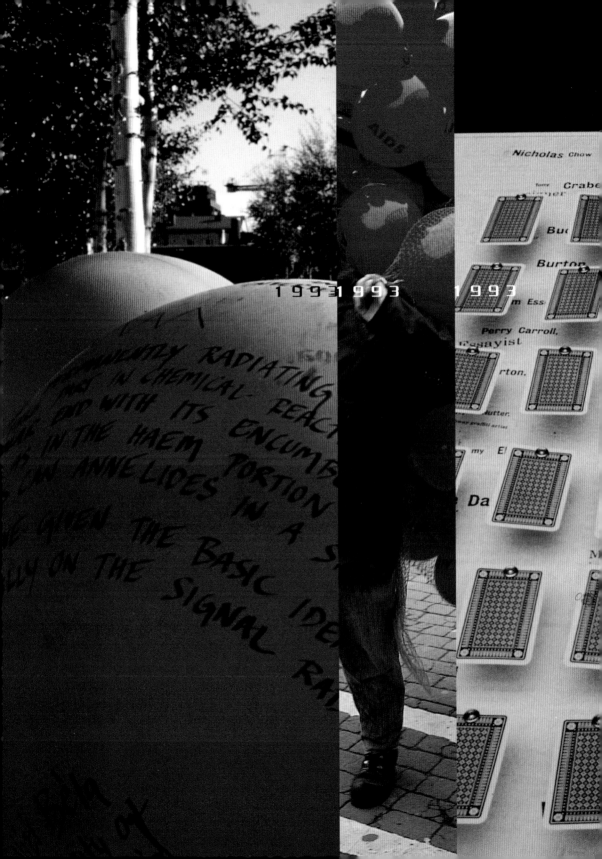

1993 1993 1993

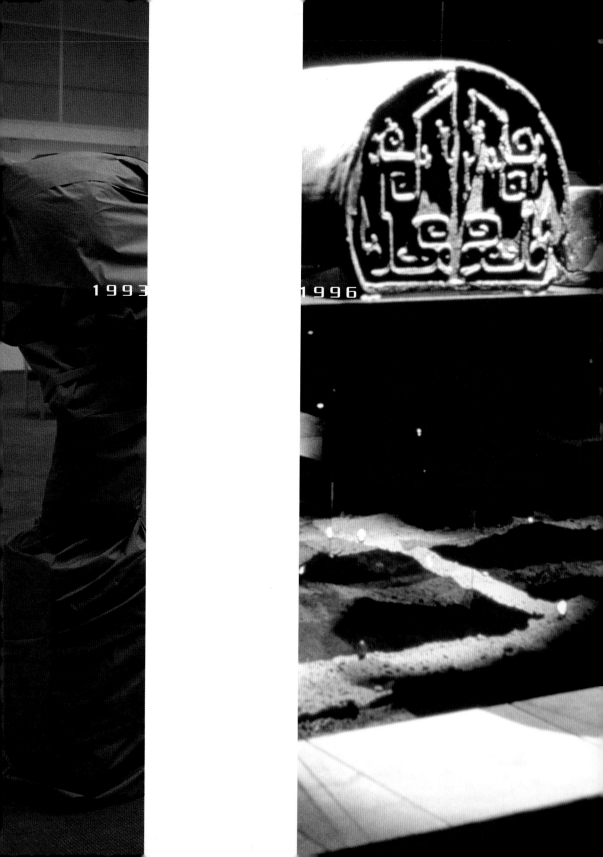

1993 1996

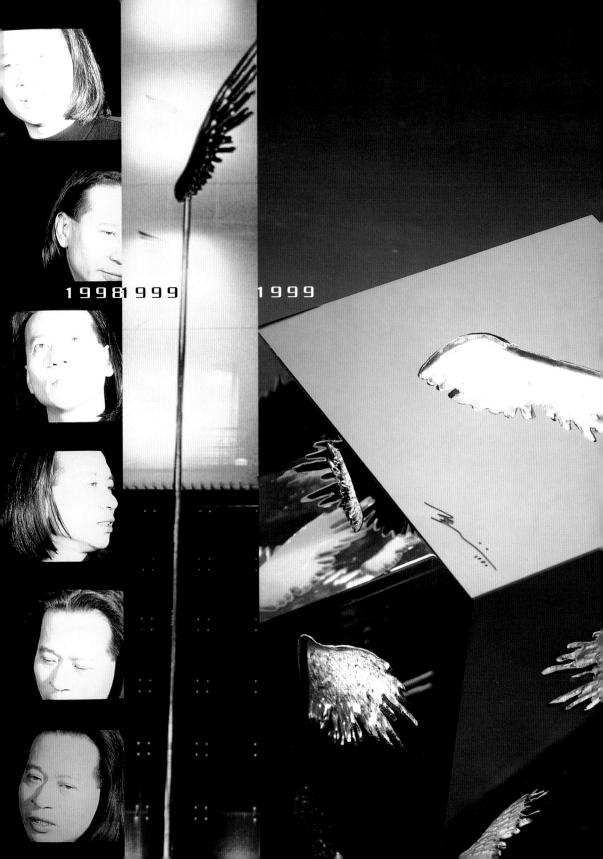

1998 999 1999

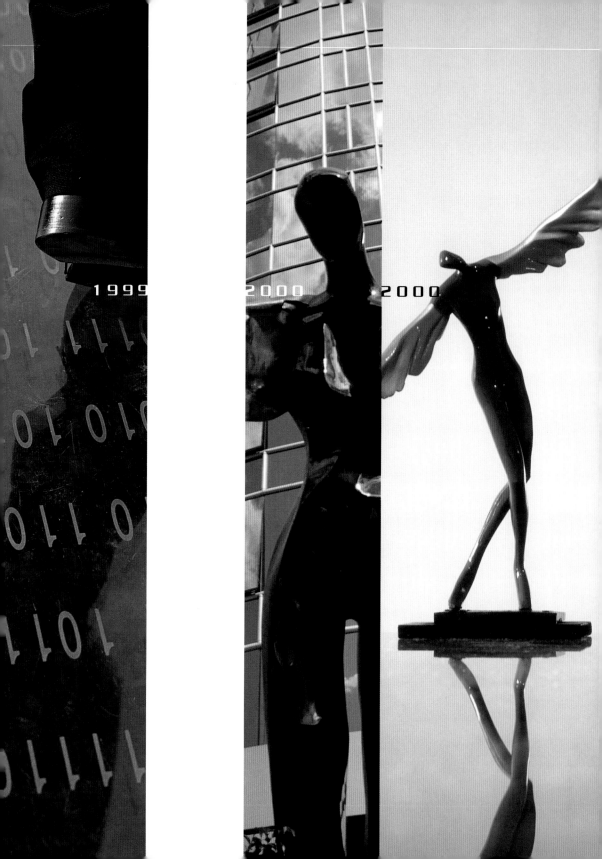

1999 2000 2000

目录

CONTENTS

作品 WORKS

赵汀阳，中国社会科学院哲学所研究员。**Zhao Tingyang**, Professor of Chinese Academy of Social Sciences. (I) Shaman 是或曾经是流行于近北极地区，如北欧、俄罗斯、蒙古、我国东北地区等的一种原始宗教精灵形象，能够神秘地自由出没于神界人间，能带来不可思议的预言，也能给人治病消灾。(I) Many people, living mainly in the northern Europe, Russian, Mongolia and northern east China, believe in the Shaman, a sort of god said to be able to freely fly in and out of both the world and heaven, bringing predictions and relieving people from dangers or sickness.

在可能世界间出没(1)

赵汀阳

A Shaman Floating Among

Possible Worlds(1)

by Zhao Tingyang

可能世界之间的对话 逻辑为什么是比较无趣的，因为它基本上都是绝对的真话，是重言(tautology)，也就是废话。这其实也是哲学家的一个烦恼：如果说出来的话总是真的，那么是废话；假如说的话确实有内容，又恐怕是靠不住的大话。艺术家要幸运得多，艺术家有正当的理由做一些与真假判断无关的事情。逻辑中的"可能世界"[1] (the possible worlds)理论经过不大合乎逻辑的解释发挥之后很适合用来谈论艺术。在这里我准备特别关注米丘的艺术意图。米丘被认为是"飘一代"的艺术总监[2]，他似乎是刻意地想表达在各种可能世界之间飘来飘去的感觉，有点像是个shaman。当然，"飘"的说法只是一种巧合，如果更哲学一些地说，他试图表达的是在各种可能世界之间神秘出没的感觉。艺术叙事(narrative)比知识描述(description)所准备表达的世界要丰富得多。对于知识描述来说，知识的对象是现实世界。现实世界是可能世界的其中一个，尽管很可能不是最好的那一个，但它具有着存在论上(ontologically)的明显性和直接性，就是说，它就在我们身边，在我们身上，它就是我们自己，而且这一点是明明白白的，因此它对于知识来说是个优势的对象，而其它可能世界包括所有存在于想象和虚拟中的或者说"反事实的"世界在知识论上则是可疑的。而对于艺术和宗教，情况有些不同，如果禁止对想象的可能世界的表现，反而是不可想象的事情。无论对于艺术还是宗教，不可理喻的东西(the absurdum)是更值得相信的——宗教思想家Tertullian曾经说，因为不可理喻，因此我乐意相信(credo quia absurdum est)，按照这个逻辑，关于艺术我们似乎也可以说，因为不合常理，因此我才感兴趣。显然人们愿意在永远不能令人满意的现实世界里想象一些非现实的事情。这里有一个有趣的问题：在知识论意义上，现实世界之外的虚拟世界是不能证实的，于是失去了真值(truth-value，即或真或假的意义)，因此是不可信的，正是这个理由使许多现代哲学家放弃关于形而上学(metaphysics)[3] 的思考；可是我们

(1) Leibniz 提出可能世界概念来解释真命题(proposition)，后来经过许多逻辑学家特别是 Kripke 的努力发展为模态逻辑(modal logic)的重要理论 (2) 见《新周刊》2000-12 期。(3) Such as analytic philosophy and empiricism.

必须注意到另一个事实，即，我们的荒谬的想象和离奇的白日梦、变态的幻想或伟大的理想以及关于过去的武断猜想或关于未来的盲目预言，虽然它们那些落在现实世界之外的所指(references)是可疑的，但是这个"胡思乱想"的行为却是现实世界中的一个事实，因此它实实在在地干涉着现实世界，比如说那些奇思异想可能会指导人们去做出妙不可言或者愚不可及的事情。实际上，略为夸大一些说，人们改变这个世界的所有主意甚至思考这个世界的所有知识体系都是基于幻想般的假设的。在这个意义上，艺术、宗教和古典哲学是对的：由于我们总必须听从某些不可理喻的想法，因此必定有某些在知识论上不可信的想法是值得相信的。艺术家，一些比较敏感的人，很容易着迷于那些不可理喻的事情和观念。包括米丘在内的许多艺术家都有着在不同的可能世界之间建立对话的自觉意识。米丘的大量作品特别是他的行为/装置和大型环境作品都显示出这种跨世界的对话意识。他往往是把一种能够蕴涵(implies)某个"彼处世界"(a world-there)的符号或形象植入"此处世界"(the world-here)，造成不同可能世界之间的可通达性(accessiblity)。这里的可通达关系不是逻辑学和知识论意义上的关系，只是借用这个概念来表达不同文化、情感、社会和生活方式的艺术对话。这种可通达关系并非现成的关系，是不现实的，因此有着不可描述的性质。艺术家似乎总是试图提醒人们，事情并非总是人们所熟知的那样，从而引起一种想象的经验。想象的经验是幸福的。甚至早在1987年，米丘就试图在一个叫做"330支蜡烛"的行为/装置中表达在一个世界里对另一个可能世界的想象：在一个中国传统样子的院子里，有条红布横过地面，爬上围墙，爬入另一个院子，红布两边是330支蜡烛，米丘自己坐在围墙下红布上。不过这个早年的作品太过直白，其中的想象显然有强迫感，特别是米丘自己在围墙下做思考状的形象有些画蛇添足。但是米丘后来的一些比较成熟的作品则相当有说服力，如"fax行动"、"七七四

十九"、"7000只气球"等。在"fax行动"(1993)中，通过传真来自全球的无数关于艾滋病的个人意见被印刷在红纸上，然后在一个通常非常安静的北欧城市中心铺成一条红路，艾滋这个可怕的可能世界和五湖四海的意见无法回避地打破了此处世界的安静和秩序，人们被诱导而产生不安，魔鬼不用现身，但好像就在身边，在人们心里。不同文化、社会、世界、心灵的对话已经是这个时代的一个重要主题，米丘1996年策划的"中国艺术5000年"欧洲巡回展览就是一个非常入时的展览。入时的话题很容易被搞成讨好人的庸俗作品，幸亏艺术家更加关心的与其说是对话的内容不如说是对话的措辞(rhetoric)，或者说，艺术在关心可能世界间的关系时并不是要介绍知识，不是要知道或让别人知道某种生活是什么样的，而是要展示一个可能世界的魅力和可通达性，因此艺术一定同时是技艺。在这个意义上，米丘把艺术解释为"艺／技术"(artech)是非常恰当的。就是说，艺术家必须通过技艺而不仅仅靠生硬地显示一个意图才能够把某个彼处世界的魅力或震撼在此处世界中显示出来。不用说，中国古代艺术的"辉煌"是众所周知的，西方人并不会因为中国古代艺术的辉煌感到惊讶(又不是发现新大陆)，西方的人类学和东方学早就规定了东方的艺术是辉煌的、神奇的、牛鬼蛇神的，同时也规定了东方的社会是专制的、神秘的和诗意的，只有专制的神秘社会才会产生牛鬼蛇神的艺术(E. W. Said对Orientalism的批判指出了西方关于东方的意象是臆想的而且顽固不化)[1]。显然，展示中国古代艺术是一件普通事情，关键是表达方式。米丘从中国黄河运去36吨黄土，铺在展厅当地面，并且把各种展品用现代装置的方式和技术组织起来，这不仅是一个艺术上的成功，而且暗示着中国世界的完整性和当代性，它不能被仅仅理解为一种古代的破碎的事情。我认为米丘不太相信纯艺术。正如人们看到的，米丘特别关心现实世界的话题，多次重复的话题是艾滋、幸福生存和未来世界的愿望诸如此类相当俗世的事情。事实上现

(1) cf. Edward W. Said; Orientalism, 1978.

在纯艺术有些像是庙里的神，"虽受祭祀，恨无灵验"(I)。其实艺术的起源以及在历史上的大多数时候的艺术都是很不纯的，从作为巫术和庆典形式到作为宗教和政治宣传到作为社会/文化批判和心理研究，艺术都有着社会意义。纯粹作为实验的艺术似乎只是现代文化的一个比较特别的产物，纯艺术可能有着某种艺术史上的价值，人们在艺术史里会记录那些难以理解的创造或与生活无关的精彩游戏，但却不会有普遍热烈喜欢它们的理由。艺术不纯的重要性在于，一种东西只有与现实世界有关才有力量(不仅艺术如此，思想学术也如此，纯粹的真理就像纯粹的艺术，当然说的都对，但人们没有必要关心)。一个作品与现实世界或生活世界的相关性(relevance)证明着它的意义，或者说，如果一个作品所表达的可能世界缺乏与现实世界的相关性，那么它缺乏交往的途径。同时，在另一方面，人们又期待在艺术中能够看到不同的可能世界，而不是现实世界平常的样子。这意味着艺术必须具有现实和想象的双重身份，于是，艺术家就不得不找到所谓"化腐朽为神奇"的方法(从中国艺术家自古就念念不忘要化腐朽为神奇这一点上看，中国艺术家是相当早慧的)。**事物显灵** 把现实世界中的普通事物魔术化，也许可以说是一种把事物"变熟为生"(defamiliarization)的技术(2)，这是化腐朽为神奇的一个基本手法。通过"变熟为生"，使事物显灵，好象变成通向另一个世界的一个通道，或者是另一个世界干涉现实世界的一个入口，在这一点上，艺术家有些像是被假定有通灵能力的巫师。按照艺术史的一般理解，巫术至少是艺术起源的最重要方式之一，而巫师则是最早的艺术家，他们被认为有神奇的能力能够出入各个可能世界，能够带来其它世界的神秘信息。当然，由于其它世界是神秘不可理解的，因此，来自其它世界的信息就只能是隐喻、象征或暗示，为了加强魅力，就尤其需要设计一些特别的表达性表演和道具。如果按照现在的语言，似乎就应该说是行为和装置艺术——事实上就是行为和装置，只是那时候不这么觉得，但

(I) 根据 Komar and Melamid 的网上作品 "The MostWanted, the Least Wanted"，五大洲数十个国家的人们最不喜欢的画是几何抽象和抽象表现主义作品。这些作品也许很有些艺术史地位，但人们也只是"抽象地"敬佩它们而不动心，显然那些作品表达的可能世界太遥远了。(2) 人类学术语。cf. Marcus and Fischer: Anthropology as Cultural Critique. I986

那些巫术，羽毛、彩衣、舞蹈和后来的教堂尖顶、彩色玻璃到现在的行为、装置和表演一样都是对人类行为、空间和表达的魅力的探索，都是行为和装置。米丘的"七七四十九，巫在芬兰"(1993)和"纸牌游戏"(1993)直接地表达了神秘通灵的跨世界关系。在"巫在芬兰"中，49个巨大的气球，而且是让人想入非非的红色，上面写着关于shaman的各种理解，在不同的钟点以不同的组合方式出现在芬兰乡村或小镇的不同地点，似乎是神秘的飘移，又是不可理解的呼唤，尤其在芬兰近极地的不寻常的光线和风景里，shaman显然在隐身活动，神灵的看不见的手在展示超自然的能力，但是我们不知道也不可能知道神灵的意图。尽管人类关于社会、历史和生活的全部知识都试图把握人类的命运，但关于命运的知识永远是不充分的，因此，在"我知道"的精神冲动之外，"我相信"永远是有着同样力度的精神冲动。当然，现在人们可能不再需要传统意义上的巫师，但是艺术家充当了另一种能够在不同可能世界之间穿行的使者，展示着不同世界的魅力，传递着恐怖、神秘和幸福的信息，而人们并不真的需要知道那些信息说的是什么，但是能够因此进入一种精神经验，在其中，人们可以感觉到"心情"(heart)而不仅仅是"心智"(mind)——西方主流哲学总是鼓励人们关注mind，依靠理性，做一个无论何时何地都一心只想把自己的利益最大化的理性经济人，这种不关心heart的思想是不能表达生活意义的[1]。艺术家往往喜欢利用一些非理性的事物，真正的意义不在于表达非理性冲动或神秘主义的胡说而在于转向对heart的关心。米丘最近的作品之一"愿望2000"(2000)讨论了非常有趣的主题"愿望"。作为这个集环境设计、雕塑、网络、建筑、装置和行为于一体的大型综合作品的一部分，米丘建立了一个网站，收集了大量关于人们在2000年对未来的各种愿望，并写在一个建筑物"愿望塔"里，立在深圳大梅沙的广阔沙滩上，附近还有一组高大的长着翅膀的舞蹈着的人像雕塑，总体气氛是"飞"，愿望当然是有翅膀

[1] 西方哲学是 philosophy of mind, 我试图论证现在我们需要一种 philosophy of heart.

的，所以人都是有翅膀的，或者说，人在没有失去翅膀时，就一定是有翅膀的[1]。愿望指向可能世界，很可能是一些永远走不到的可能世界，这正是人类生活的意义。"我希望"甚至是人类最深刻的精神冲动。康德(kant)说人类只有很少几个根本问题："我能够知道什么？"、"我应该做什么？"尔后是"我可以期望什么？"。愿望的问题可能是最深刻的，因为"所有的愿望都指向幸福"[2]，显然人们所想要的也就是这个事情。但是愿望并不清楚，至少在现代生活里，愿望变得越来越不清楚。正如电影"麻将"里说的：每个人都不知道自己想要什么，每个人都在等别人告诉他需要的是什么，而既然每个人都不知道想要的是什么，因此告诉别人应该要什么就只不过是骗他。看来艺术家比教育者要诚实一些，米丘只想创造一个有利于产生愿望的气氛，而不打算告诉人家应该有什么样的愿望。**SYNART(综合艺术)的转向** 在全球化的经济／文化运动的背景下，所有人都感觉得到社会生活变得复杂了，文化资源和问题也更多，社会的各个方面的互动得到强调，运作规模增大。艺术家从来都是敏感的，他们当然更意识到这一点。可以说，在当代的背景下，艺术和思想一样都遇到了表述的危机(the crisis of representation)。艺术的各种传统表达方式，绘画、舞蹈、雕塑、表演、摄影、行为、装置等等，都仍然有着潜力和吸引力，但无论如何艺术家希望能够有机会在更大的时空里形成更有力量的表述方式。在思想观念上，我相信一种综合文本(syntext)[3]更能够表达当代／未来的问题，同样，在艺术上，我相信综合艺术(synart)也更有表达的容量。网上作品和大规模环境艺术就非常适合于展开综合艺术，事实上，人们对internet巨大兴趣和关于自然环境的新态度和观点正在鼓励艺术家创作网上作品和大规模环境艺术——我相信它们是未来最有希望的艺术。网上作品和大规模环境艺术都具有容纳各种传统艺术表达形式的能力，而且具有非常重要的互动性(interactiveness)，它有助于形成能够满足Ryle/Geertz理论所主张的

(I) 古希腊哲学家（大概是 Eubulides）曾经诡辩说：你没有丢失的东西，你就仍然有。你没有丢掉角，所以你长着角。(2) cf. Kant: Critique of Pure Reason. (3) see my paper: Pour un Syntext. in Alliage No.4I–42. France.

文化上的"深描"(thick descriptions)[1]。也许更重要的是，它们是真正的公共艺术，具有目前所能够设想的最强的公共性。人类所有最好的作品都应该可以公开展示同时被自由地理解和参与，这才是"文—化"(the cultivation of culture)的真正原则，否则就变成教育、宣传、垄断。在这样的理解下，我非常看好米丘近期的艺术意图。米丘的"愿望2000"就更是一个包含有网上作品、雕塑、装置、建筑在内的大规模环境作品。这个作品目前还没有完成，从设计图上看，应该是有动人的效果的，沙滩上巨大的有翅膀的群像与永远的海风有着良好的关系，而有着多媒体装置的高塔又在传统的灯塔和比大海更广阔的网络世界之间建立了一种跨越。环境艺术对艺术家的要求除了创造还要有对现存细节的理解和宽容的处理，这就像和他人建立关系一样需要磨合、理解、适应而形成和谐，无论是朋友、情人或亲人。环境艺术正是显示了人、自然和技术的和谐合作。在上海宁寿大厦的环境设计中，米丘对原来在大厦前面的一个古旧牌坊的处理方法既充满善意，又不守旧：几经考虑后，牌坊被整体平移了26米，在新建筑和这个旧牌坊之间安排了一块18米的大玻璃，使古旧和现代通过透明体玻璃建立起一种若有若无的联系，并完成和谐过渡。当然涉及到环境艺术，其中的工程技术含量是必不可少的，幸而米丘有建筑系的学科训练，使他能在感性的自由想象之后，有相应技术方案使之成型和实施。大型艺术，无论是环境艺术还是网上艺术，都是因为能够简洁地处理复杂关系而形成魅力的。这充分表达了这个时代的性质：事情非常复杂(所以有魅力)但是必须简洁把握(否则就变成混乱)。看来米丘很明白这一点。

(1) cf. Geertz: The Interpretation of Cultures. 1973.

A CONVERSATION BETWEEN THE POSSIBLE WORLDS Why is logic so uninteresting? Because it is absolute truth, because it is tautology, basically it is superfluous words, true but nothing new. Actually this is a problem for most philosophers: If what we speak is always truth, then we speak superfluous words, but if what we want to express actually has some meaning, then we use unreliable language. Artists are luckier. They have a justified excuse to do things outside of the question of the difference between true and false. The logical concept of the possible worlds[1], having been given some explanation, seems very appropriate in discussing art. Here I intend to focus on Mi Qiu's artistic intentions. Some people have spoken of Mi Qiu as the artistic chief of a floating age[2]. It seems as though he is striving to give expression to the feeling of floating back and forth between the possible worlds, almost as though he were a shaman. Of course, the word "floating" is just a coincidental expression, to be more philosophical about it one could say he is striving to express the feeling of mystical appearance and disappearance in the possible worlds. The worlds that are or prepared to be expressed through artistic "narrative" are much richer than those expressed through epistemological "description." The world of reality is among the possible worlds, although it is quite likely that it is not the best. However, it is ontologically obvious and direct. In other words, it is right next to us, it is in ourselves, and this is exceedingly clear and evident, therefore it is an advantageous object to knowledge. In contrast, all of the other worlds exist in our imaginations, in our suppositions. One might even say they are

(1) Leibniz firstly created the concept "possible worlds" to be used in the definition of the true proposition. It has later become an important concept in the modern modal logic. (2) cf. New Weekly, No.2000–12.

'anti-factual" worlds, skeptical and even doubtful from the perspective of true knowledge. But in terms of art or religion the situation is quite different. One truly unimaginable situation is the outlawing of the expression of imagined worlds. Whether it is in terms of art or religion, the absurdism is even more worthy of our trust. The religious thinker Tertullian once said "credo quia absurdum est" (because it is absurd I willingly believe in it). To follow this idea we can say of art that it makes us happy precisely because it is not in keeping with usual reason. Of course, people want to dream up a few impossibilities in this world in which we can never be completely satisfied. Herein lies an interesting question: No supposed worlds that lie outside the real one can be verified from the epistemological perspective. And they are not trustworthy for their lack of the conditions to have their truth-values (for a thing to be true or false). Because of this, many modern philosophers have given up their metaphysical thought[I]. But we must also attend to a different fact: our wildest imagination and craziest daydreams, abnormal fantasies or noblest ideas, even our arbitrary hypotheses about past occurrences and blind predictions for the future are all doubtful because they lie outside the real world. But these strange thoughts are in fact part of the real world so they are realistically involved in the real world. For example those strange ideas and weird thoughts might lead one to do the most amazing or the most ridiculous things. Really, in even larger terms, I'd venture to say that every action, and even every thought and effort made to change the world, all derive from this fantastic imagining. In this line of thinking, art, religion, and ancient

(I) Such as analytic philosophy and empiricism.

philosophy are all correct because we have to heed a few absurd thoughts. Therefore there are some ideas that are impossible to believe from the standpoint of true knowledge or science but truly worthy of belief. Artists, some comparatively sensitive people, are easily absorbed in those absurd thoughts and ideas. Many artists, including Mi Qiu, have developed a self-consciousness of establishing a dialogue among the possible worlds. The great majority of Mi Qiu's works – especially his performance/installation and large-scale environmental pieces – all display this dialogue of leaping among the possible worlds. He often infuses the world here with a symbol that implies a world there, creating the accessibility between different possible worlds. This relationship of accessibility here is not exactly a logical relationship as it is always defined in the logic; it is just an artistic conversation borrowed to express different cultures, feelings, societies, and lifestyles. This kind of relationship of accessibility is not an immediate relationship; is not realistic, so it has an indescribable quality. The artist is always striving to remind people that things are not always as people to believe them to be. And from this he creates a kind of imaginative experience. This imaginative experience is blissful. In 1987 Mi Qiu expressed the imagination of one world from a different world with his piece "330 candles." In a traditional Chinese courtyard he laid out a red cloth, crossing the yard, traversing a wall, and passing into the neighboring courtyard. The cloth was bordered on both sides by 330 candles, and Mi Qiu himself sat on the cloth under the wall. However this early piece was too straightforward and some of the imagination in

the piece was forced. Mi Qiu sitting in thought on the red cloth was especially too much. But many of Mi Qiu's later works are very persuasive, for example pieces like 'Fax Action," "7x7, 49," and "7000 Balloons." In "Fax Action" (1993) Mi Qiu collected faxes from countless people all over the world discussing their opinions on AIDS and then he photocopied them onto red papers. Then he pasted them together, forming a road in the center of a very peaceful Northern European city. This frightening possible world of AIDS and the opinions of people from all over the world irretrievably disrupted the peace and order in the life/world here. People were drawn in and then made to feel uncomfortable. The devil didn't show itself, but it was as though he was there, in people's hearts.As the dialogue between different cultures, societies, worlds and spirits are already an important issue in this age, the traveling exhibition Mi Qiu organized in 1996 in Europe, "5000 Years of Chinese Art," was well in keeping with the times. These timely topics are easily vulgarized. But fortunately the artist was more concerned with rhetoric than content. In other words, one can say that when art is concerned with the relationship between possible worlds it is not concerned with an introductory knowledge, it is not an attempt to know or make others know what a certain life is like. Rather it is an attempt to show the charm and accessibility of another possible world. Therefore art must at the same time be artistry. In these terms, Mi Qiu's explanation of art as artech is really acceptable. In order to make the charm or impact of a world there appear in the world here an artist must use technique, not merely rely on unnatural methods of display. It goes

without saying that everybody recognizes the magnificence of ancient China; Westerners will not be surprised at this artistic magnificence (it is not like the discovery of the new world). Western anthropology and Orientalism have early on defined Eastern art as magnificent, mystical, and spiritually strange. At the same time they have defined Eastern society as autocratic, mysterious, and poetic. Only this kind of autocratic and mysterious society could produce such spiritually different art (Edward Said's critique of Orientalism points out that the West's outlook on the East was suppositional and obstinate[1]). Obviously, showcasing ancient Chinese art is a very ordinary thing to do, the main importance lies in how it is done. Mi Qiu took 36 tons yellow earth from the Yellow River and used it as the ground in the exhibition hall. He also used contemporary installation methods and techniques to display the pieces. This is not only an artistic success, it also hinted at the completeness and modernity of the Chinese world; it cannot only be understood as an ancient, crumbling tradition. I don't think Mi Qiu believes in pure art. The issues he is most concerned with are topics that exist in the real world, topics like AIDS, happy lives, hopes, and dreams of the future. All of these very plain, contemporary issues recur frequently in his works. Really, contemporary pure art is like a god in a temple, "although you may worship it, it sadly does not always respond.[2]" Actually, most art throughout the ages is not pure art, from the mystical and ritual to the religious and political, or even cultural/social critique and psychological research, all art forms have social meaning. Pure art experiments are a particularly exceptional product of modern

(1) cf. Edward W. Said: Orientalism. 1978. (2) In an on-line work by Komar and Melamid, The Most Wanted, the Less Wanted, a report saying that the people almost all over the world dislike modern abstract paintings, because of their irrelevance to our life world.

culture. Perhaps this pure art has a certain art historical value, but there won't be any more persuasive reasons to like it. It is important for art not to be pure because in order to be powerful works must have some kind of relationship to the real world (This applies not only to art, but also thought. Pure truth is just like pure art – of course everything one says may be correct, but if so people have no reason to care about what is said). An artwork's meaning is proven through its relevance to the real world and real life, in other words, if the possible world expressed in an artwork lacks a relevance to the real world, then it lacks a channel for communication. Simultaneously, people expect to see different possible worlds in works of art, not only the normal face of the real world. This means that art must have real and imagined qualities, so artists cannot avoid using the techniques of the magical changing the ordinary into the special (Since ancient times Chinese artists have been endlessly repeating this mantra. On this point they showed their exceptionally early wisdom). **THE SUPERNATURAL PRESENCE OF A THING** The process of making ordinary things magical can be described as a technique of defamiliarization[1]. Making the supernatural presence of things felt through a process of defamiliarization is like opening a path to a different world, or it is like an opening to the real world for things from a different world. On this point, artists have been seen as sorcerers with the power to get through to different worlds. In art historical terms, sorcery is one of the main foundations of art, and sorcerers are the earliest artists, believed to have mystical power that enabled them to cross to all sorts of mystical worlds,

(1) An anthropological term. Marcus and Fischer: Anthropology as Cultural Critique. 1986.

and the ability to bring back mystical information from those worlds. Of course, because the information from those other worlds was so mystical that it couldn't be understood it came as metaphor, symbol, and hint. To increase its charm it had to develop special performances and props to express it itsey–if we use today's terms we almost have to call it performance or installation art. And factually it is performance and installation as it is, only back then they couldn't see it that way. Sorcery, feathers, colorful clothing, dancing, and later church steeples and stained glass windows, all the way up to today's performance, installation, and acting are all human behavior, all experiments in the expression and staging of charm; theses are all performance and installation. Mi Qiu's works, "7x7, 49 Shamans in Finland," (1993) and "Paper Card Game" (1993) directly expressed the mystical leaping between worlds. In "A Shaman in Finland," 49 bright red balloons were imprinted with all sorts of sayings and understandings of shamans, and at different times throughout the day released into the air over different places in Finland's small towns and countryside. It was a mystical moment, a calling impossible to be understood, especially in the strange sunlight of a place so near the North Pole. Shamans hidden and active, mysterious invisible hands displaying supernatural power that we do not know, have no way of understanding. In terms of knowledge of society, history, and life, people want to control human fate, but in terms of fate people will never know it all; so in addition to the force of the spirit of "I know" there is also always the same strength in the force of the spirit of "I believe." Of course, people today perhaps no

onger need the traditional sorcerer, but artists have become the figures who can cross over to different possible worlds and display the charm of these worlds and transmit scary, mystical, and blissful information. People really don't need to know what that information is saying, but they can enter a kind of spiritual experience from it. In it people can feel the heart, and not only the mind. Western philosophy encourages people to focus on the mind, relying on reason, encouraging people to remain rationally focused at all times on how to maximize one's own interest, this kind of lack of focus on the heart cannot express the meaning in life[1]. Artists usually like to use a few things that are not in line with reason; true meaning does not lie in the expression of irrational excitement or mystical nonsense, rather it lies in a concentration on the concerns of heart. Mi Qiu's recent work "Wish 2000" (2000) discusses the very interesting topic of hope. Combining all the different elements of environmental design, sculpture, the internet, architecture, installation and performance, Mi Qiu set up a web page on which he collected people's hopes for the year 2000. He also wrote them on a piece of architecture named the "Hope Tower" situated on a vast beach in Shenzhen's Dameisha, and in the area there was also a group of tall sculptures of persons with wings dancing. The overall atmosphere was one of flight. Of course hope has wings, so people all have wings, or perhaps one should say before people lost their "wings" they had wings[2]. Hope points to a possible world, very likely a possible world that is impossible to get to, this is the meaning of human life. "I hope" is the deepest excitement in the human spirit. Kant

(I) The western philosophy is mainly a philosophy of mind. I am arguing that we should develop a sort of philosophy of heart. (2) A Greek philosopher, supposedly to be Eubulides, argued that you have something since you have not yet lost it. And you must have a horn on your head since you have never lost it.

said people only have a very few basic questions: "What can I know?" "What ought I to do?" and finally "What can I expect?" Perhaps the question of hope is the deepest, because "all hope points to happiness.[1]" Obviously this is just what people want. But hope isn't really clear, at least in modern life, hope is getting more and more unclear. Just like in the movie Mah-jong, "Nobody knows what they want, they are all waiting for someone else to tell them what they want. And since nobody knows what they want, when they tell others what they should want it's nothing but a lie." It seems artists are a little more honest than educators. Mi Qiu just wants to create an atmosphere rich in hope; he does not want to tell people what they should hope for.

THE SYNART TURN Against the background of a global economy and culture, everybody feels that the change in social life is confusing and complicatied; cultural new sources and problems are also greater, all aspects of social movement are stronger, and the range of movement has increased. Artists have always been sensitive, so of course they feel this more strongly. One can say that against this modern background both art and thought have come upon the crisis of representation. Traditional forms of artistic expression – painting, dance, sculpture, acting, photography, performance, installation, etc. – all still have potential and power of attraction, but regardless, of this artists still hope for the opportunity to put on even larger scale and more powerful means of expression in even greater spaces. In terms of thought, I'm confident that syntext[2] can express the problems of today and the future, and at the same time I am confident that in the field of art synart will

(I) cf. Kant: Critique of Pure Reason. (2) see my paper: Pour un Syntext. in Alliage No.4I–42, France.

have more powerfully expression. Works on the web and environmental art are particularly suited to synart. Realistically, people's interest in the internet and new attitudes toward the natural environment are encouraging artists to move to the web and the environmental art. I believe the greatest hope for art lies here. Along with the capabilities of more traditional artistic modes, art on the web and large scale environmental art both also have an important interactive-ness, they both help create the thick description[1] theorized by Ryle and Geertz. Perhaps more importantly, they are both truly public art; of the existent powers of imagination they are the most public in nature. All the greatest works of art should be able to be exhibited openly and freely understood and experienced by all, only this is the true principle of cultivation of culture. Otherwise, everything will turn into education, propaganda, and monopoly. With this understanding, I truly appreciate Mi Qiu's recent artistic strivings. His "Wish 2000" is a great example of environmental art, encompassing internet art, sculpture, installation, and architecture. From a design perspective it has the power to move people. The group of winged figures on the beach has a good relationship with the timeless sea wind, and the mixed media tower creates a leap between the two worlds of the traditional lighthouse and the vast world of the internet. An artist's demands in working with environmental art are not only those of creativity; it is also a way to deal with the scenes in contemporary life, exactly like establishing a relationship with another person. It takes adjusting, understanding, and adapting to establish harmony, whether it is between friends,

1) cf. Geertz: The Interpretation of Cultures. 1973.

relatives, or lovers. Environmental art shows the harmonious cooperation of people, nature, art, and technique. In the environmental design of Shanghai's Ningshou Building, Mi Qiu dealt with an old chastity arch standing in front of the building in a way that is both rich in meaning and not at all conservative. After much thought, Mi Qiu moved the arch 26 meters and constructed an 18 meter piece of glass in between the old and new structures, establishing a misty relationship between the past and present through this transparent glass, completing a harmonious transition. Of course when working with environmental art the demands of engineering techniques are great, so it is fortunate that Miqiu studied architecture. After Mi Qiu develops an idea he has the tools and the techniques to realize the project. The charm of large-scale artwork, whether it is environmental art or art on the internet, lies in its ability to deal simply with complicated relationships. This completely expresses the qualities of this age. Things are totally complicated (and therefore charming) but we must simply gain control of them (or all will become chaos). It seems that Mi Qiu is clear on this point.

作品　　　　　　　　WORKS

1987

330 支蜡烛

330 Candles

1987

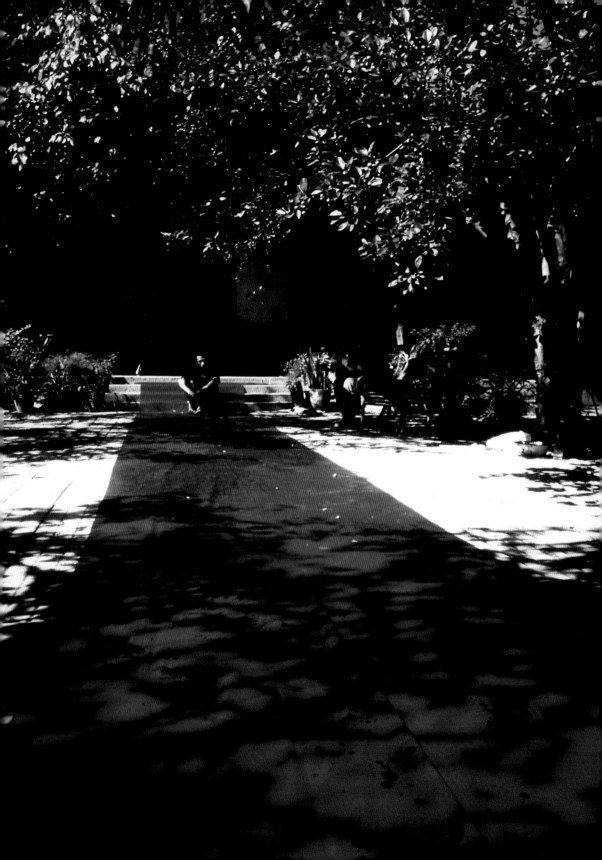

在一个中国传统的四合院中铺一道宽2米长33米的红布，红布横过地面，爬上围墙，进入另一个院子，红布两侧点燃330支蜡烛，米丘本人在红布上打坐45分钟。整个过程有录像记录。In a traditional Chinese 'siheyuan', a red cloth 2 metres wide and 33 metres long was spread over the ground and across the boundary wall into the neighboring courtyard. The cloth was bordered on both sides by 330 lit candles, and Mi Qiu himself sat in meditation on the cloth for 45 minutes. The whole process was video-recorded.

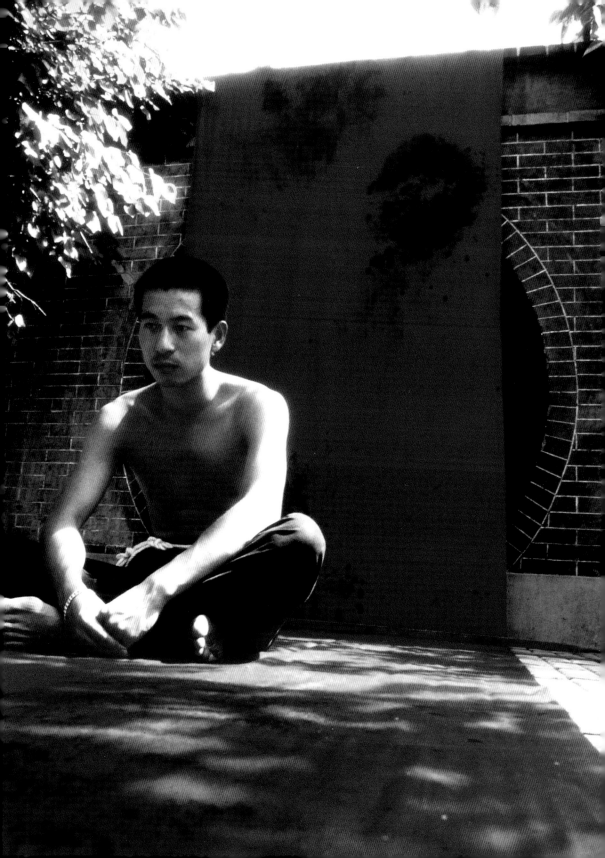

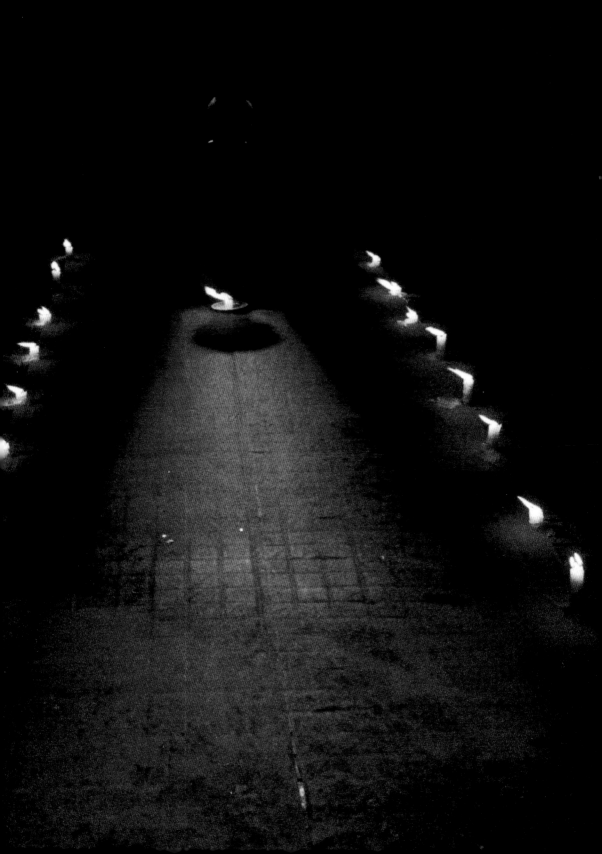

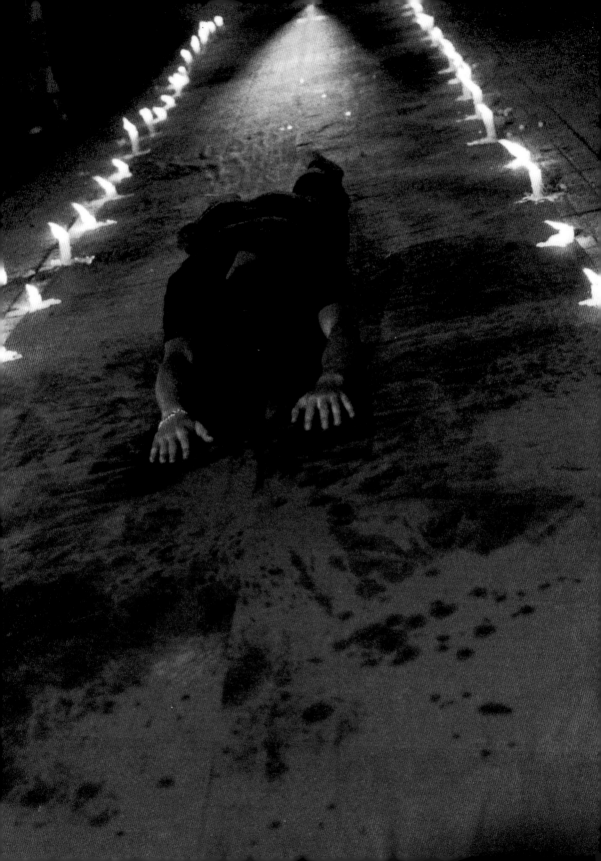

这个早期作品是在一部拍摄米丘的电影中完成的，有着浓厚的85新潮美术的特征，注重仪式感和东方式的禅思，同时也体现了米丘后来作品中一贯的神秘主义倾向。This early work, completed as a part of a film about Mi Qiu, bears the imprint of the New Wave Movement of '85, reflecting the importance attached to ceremony and the deep meditation of Orientalism. It also suggests a consistent mysticism rooted in his subsequent works.

1993

FAX行动

Fax Action

1993

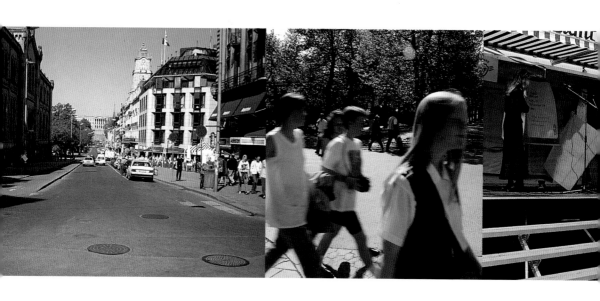

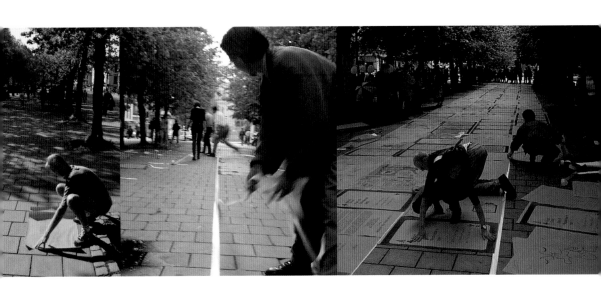

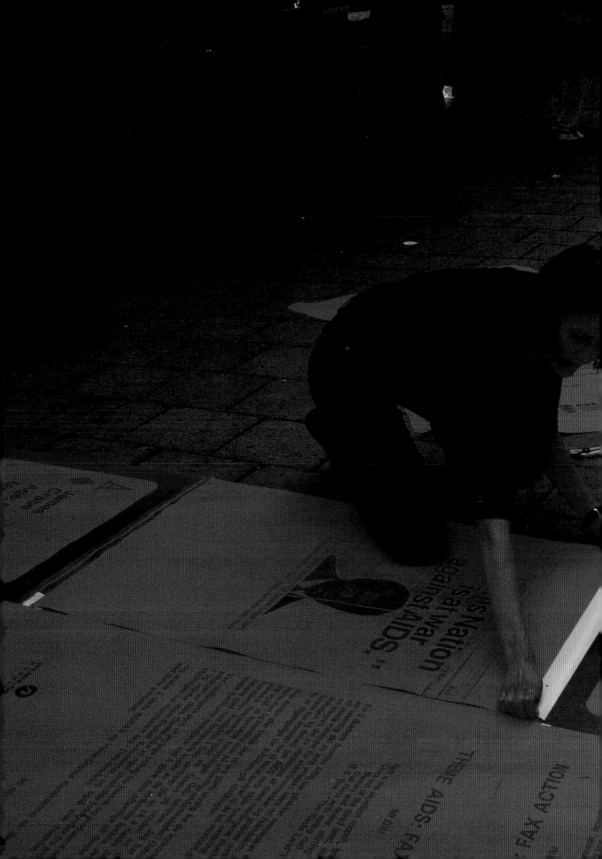

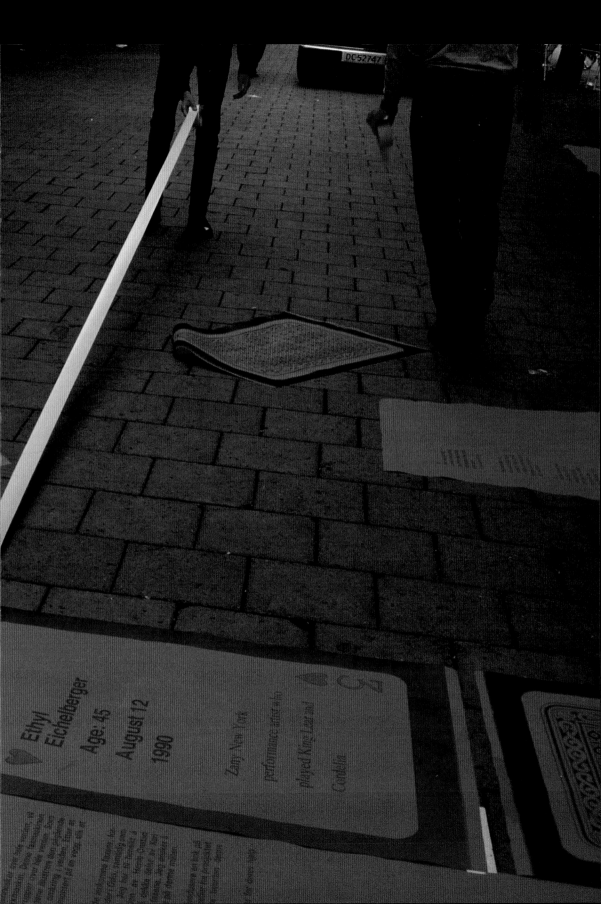

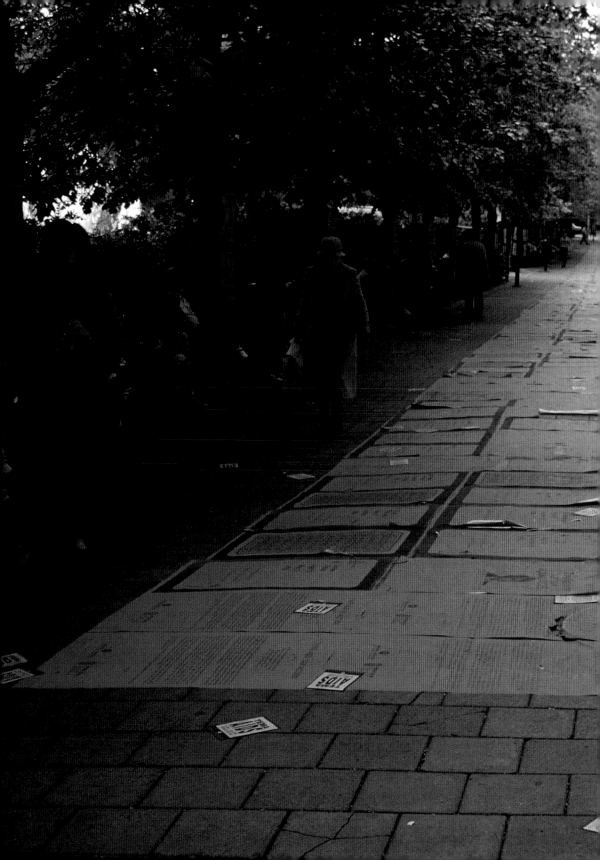

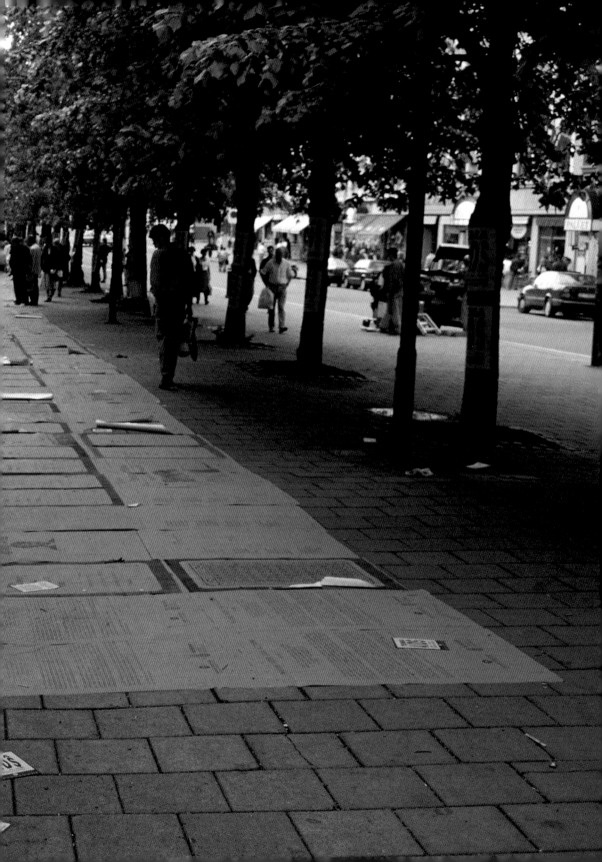

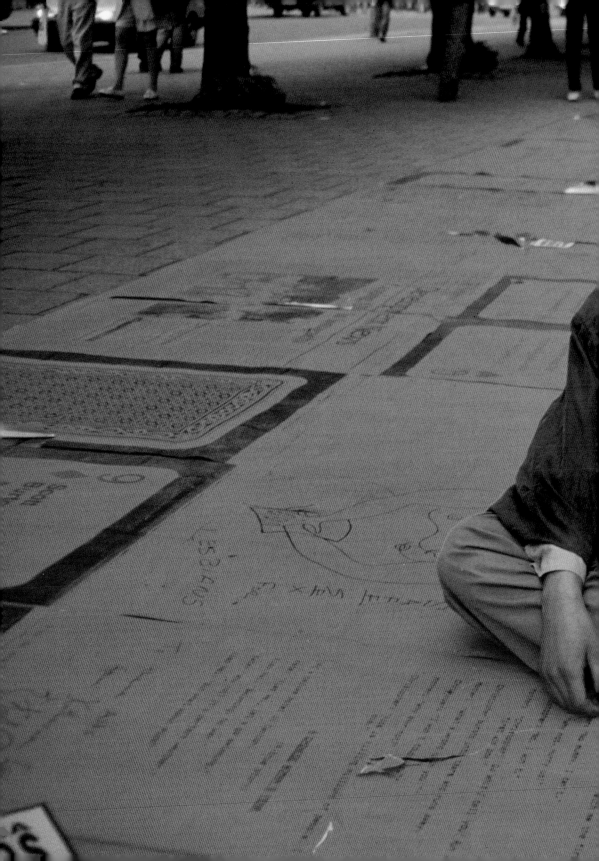

向全球发出2000份邀请,请不同的人对艺术家所拟订的关于艾滋病和人类生存的若干问题发表意见,在不到三个月的时间中共收到上千件传真,其中包括世界各地的政治家,科学家,艺术家,宗教人士,同性恋者,艾滋病患者,医生甚至尼日利亚的总统。米丘将这些传真印刷成1米X 0.6米的桔红色海报,粘贴在一起,在地面铺设长168米,宽6.6米的通道,观众可以自由地穿过通道。展览地点在奥斯陆市国家议会大厦和王宫之间,时间是挪威国庆日的前两天,共有大约60万人观看了这件作品,在全欧洲的媒体上引起了轰动。Mi Qiu sent 2000 invitations to a diversity of people around the world, asking their opinions on AIDS, human lives and other issues. In less than three months, he collected thousands of faxes from politicians, scientists, artists, people of religious conscience, homosexuals, AIDS patients, doctors and even the President of Nigeria. He then reproduced them as posters 60 cm by 100 cm, and pasted them together, forming a passage 66 meters by 168 meters between the National Parliament Building and the Palace in Oslo, the capital city of Norway. This remained in place for two days over the Norwegian National Day. The passage, allowing people to pass through freely, attracted about 600,000 visitors and created a sensation in the of whole Europe.

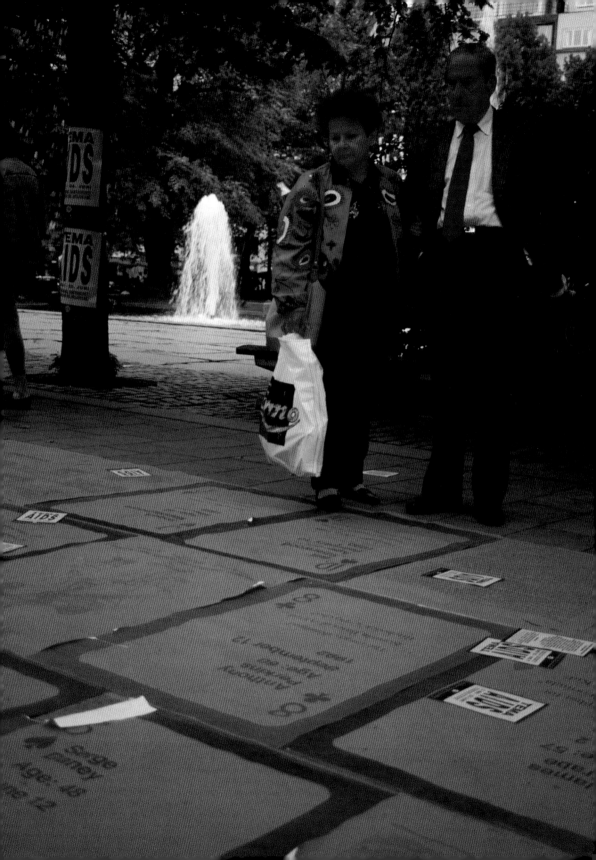

9♠

Craig
Russell

Age: 42

October 30

1990

Flamboyant er

rsor

Q♥

Freddie
Mercury

Age: 45

November 25

1991

Playfully decadent lea

singer and lyricist for

rock band Queen

3♠

Serge
Daney

Age: 48

June 12

1992

French film critic and

editor of the influential

journal Cahiers du

Cinèma

HENIE
KUNST

THEME AID

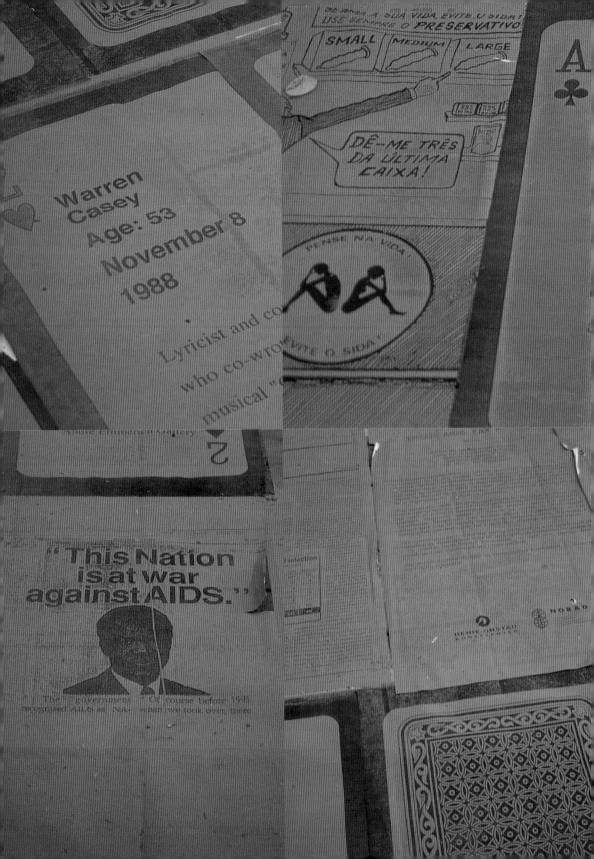

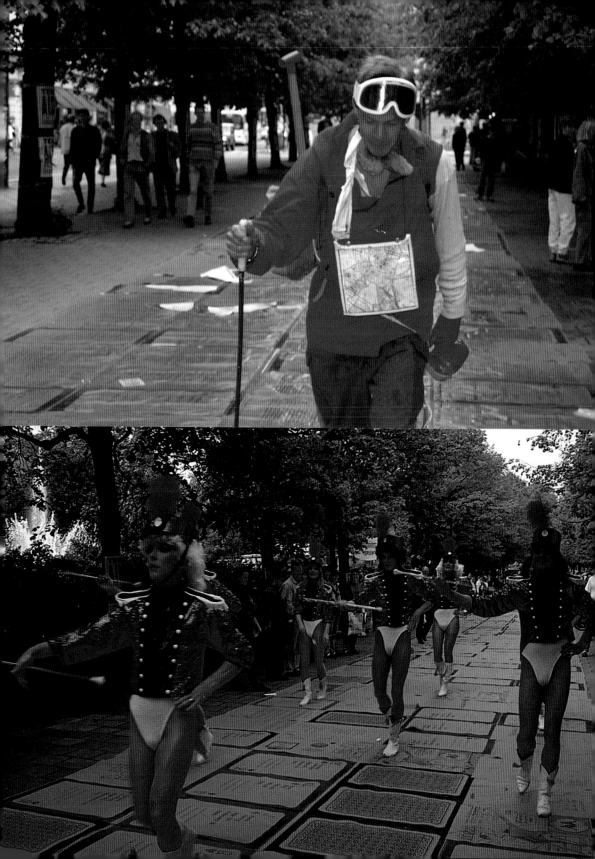

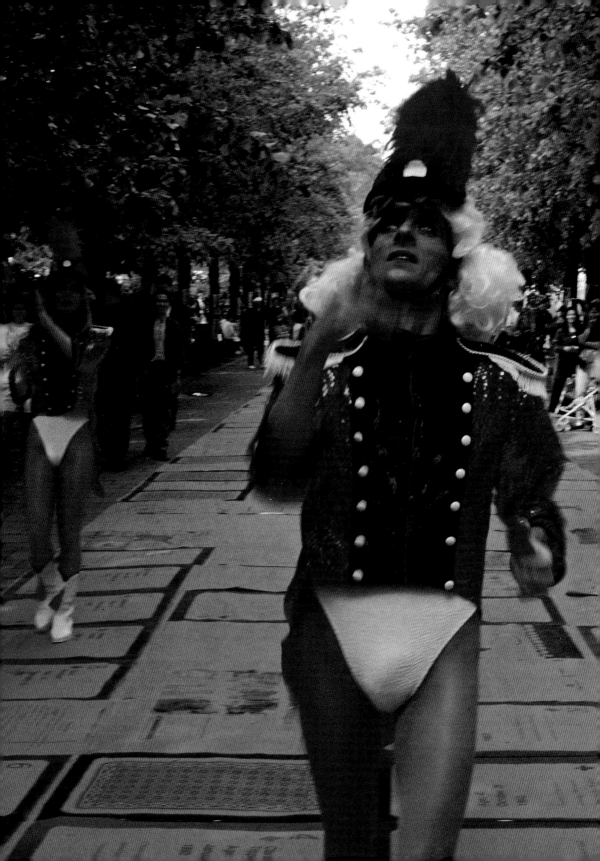

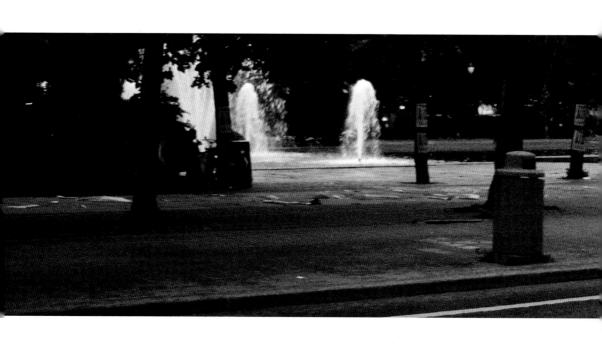

FAX行动展示了米丘作品中的另一种倾向，即作为一个艺术家的强烈的社会责任感。这件作品与米丘新近的作品《愿望2000》一样使用了现代的通讯手段，调动公众参与作品的创作和完成。从这件作品中我们可以看到，米丘很早就敏锐地抓住了这个时代的特征：民主和互动。"Fax Action" revealed another theme in his work. That is his keen sense of an artist's responsibility to society. This work, like the project "Wish 2000", employed modern means of communication and mobilized the general public to participate in its creativity and production. This work shows how Mi Qiu grasped this idea early on of democracy and interaction.

1993

七七四十九，"巫"在芬兰

7x7, 49 Shamans in Finland

1993

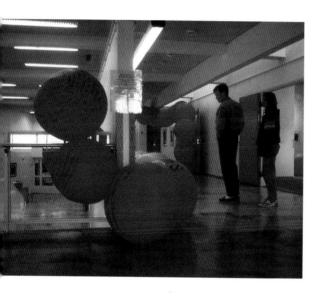

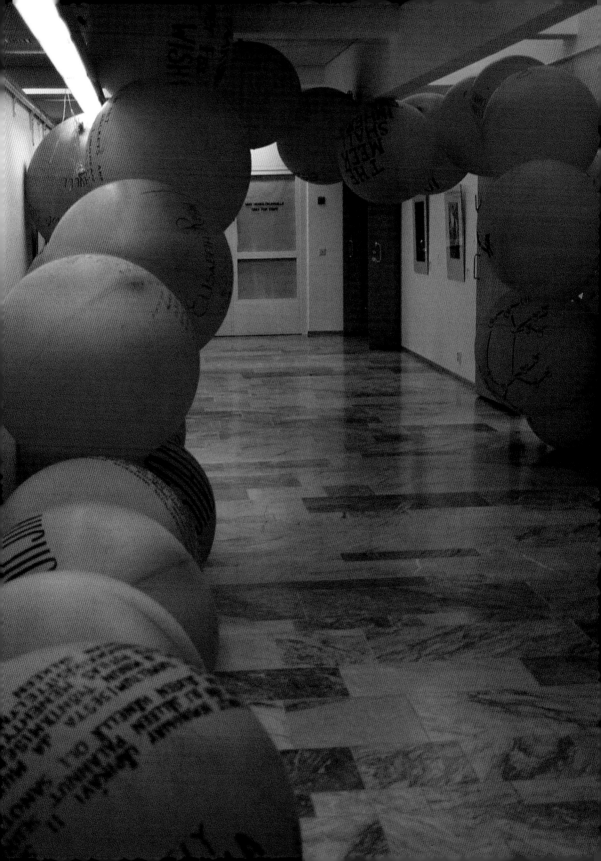

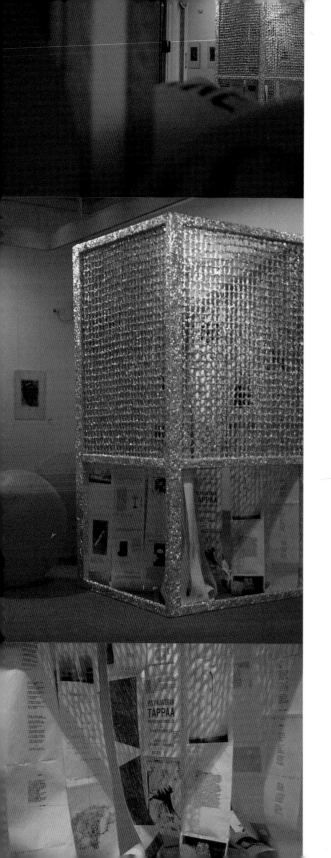

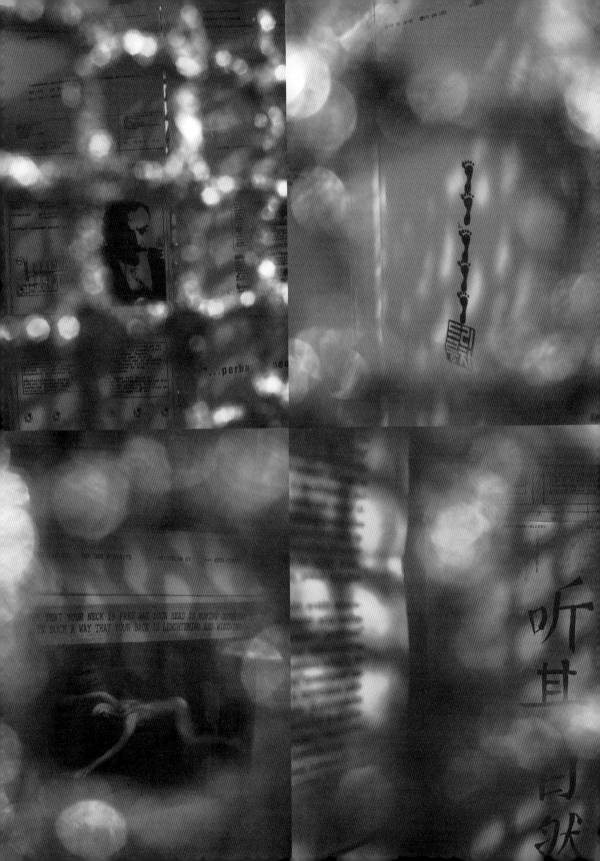

...perha...ee...

...THAT YOUR NECK IS FREE AND YOUR HEAD IS MOVING FORWARD
...SUCH A WAY THAT YOUR BACK IS LENGTHENING AND WIDENING...

听
甘
司
状

49个巨大的粉红色气球，每只气球上印刷着由十三个儿童在各种Shaman的书籍中自选出关于SHAMAN的各种注释，在7天中出现在托尼美术馆及芬兰和瑞典交界的公园，超市，街道等不同场合。每天午夜12点更换场所。49 large pink balloons, printed with a multitude of sayings and revelations of shamans selected by thirteen children from different books on shamans, were released into the air over different places such as the Tony Art Museum of Finland, and the parks, supermarkets and streets on the adjoining Swedish border at different times during a seven-day period. Locations were changed at midnight.

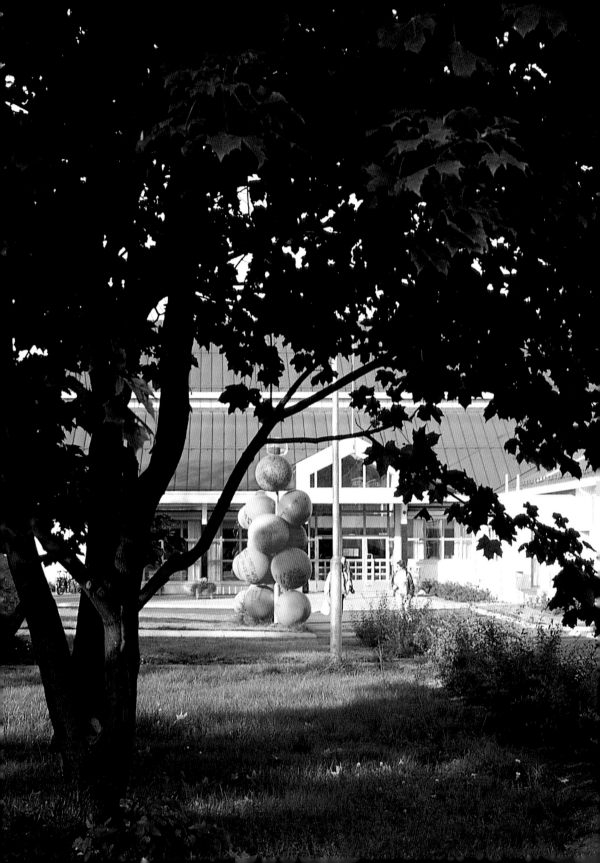

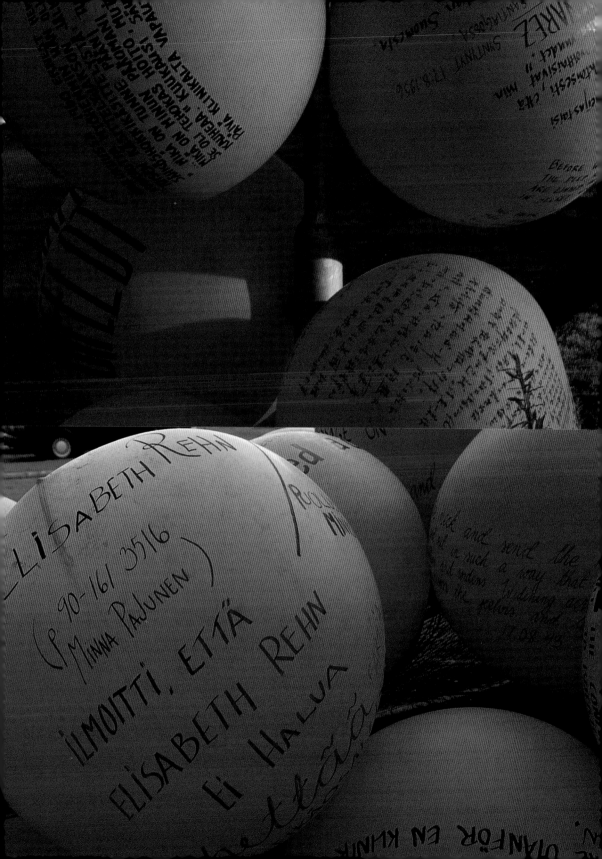

oody reality of the
he sacrifice repres
han life, heavier

e found ourse
e of erotis
eally is refer
as Venus
venus as l

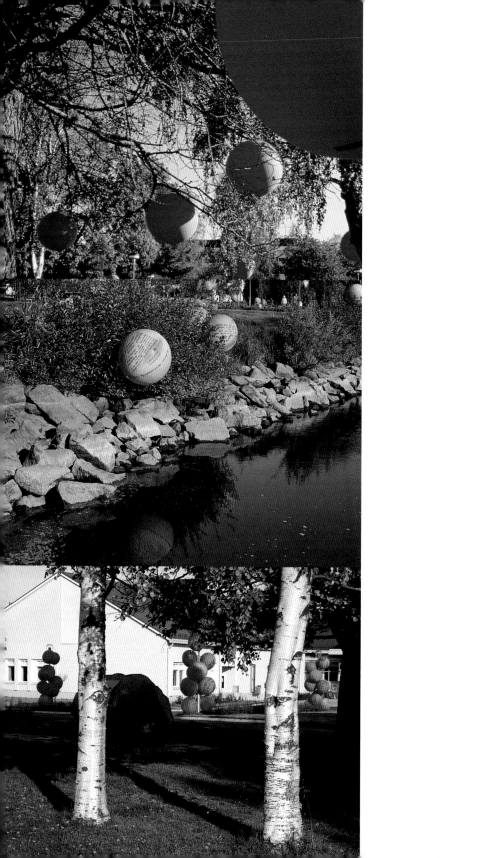

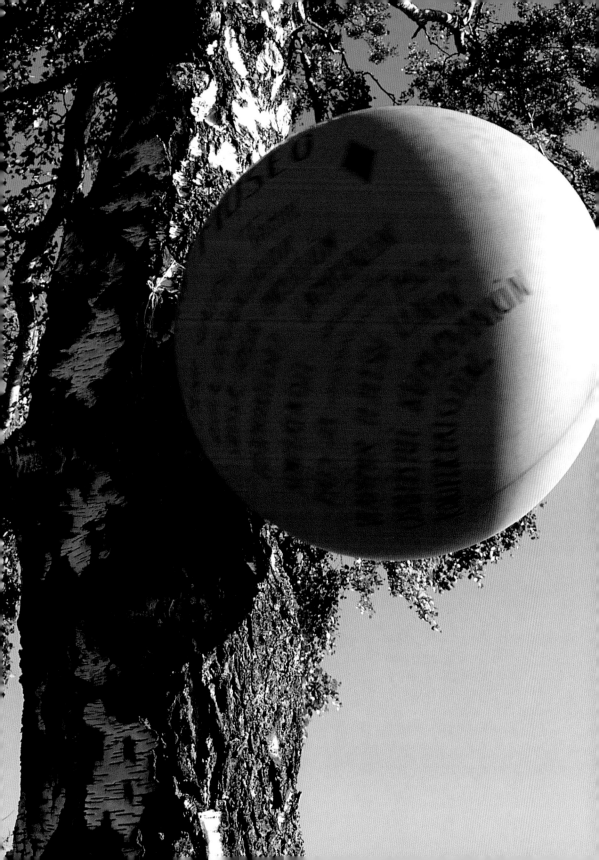

RADIATING INTO THEIR SURROUND
IN CHEMICAL REACTIONS. THEY BIND WELL WITH
AND WITH ITS ENCUMBERED ION IS SOMEWHAT AKIN
IN THE HAEM PORTION OF HAEMOGLOBIN WHICH CA
CAN ANNE LIDES IN A SIMILAR WAY. THE
GIVEN THE BASIC IDEA FOR THE
ALLY ON THE SIGNAL RADIANCE. SC

EBRATES KNOWN AS AN

Béla
ox

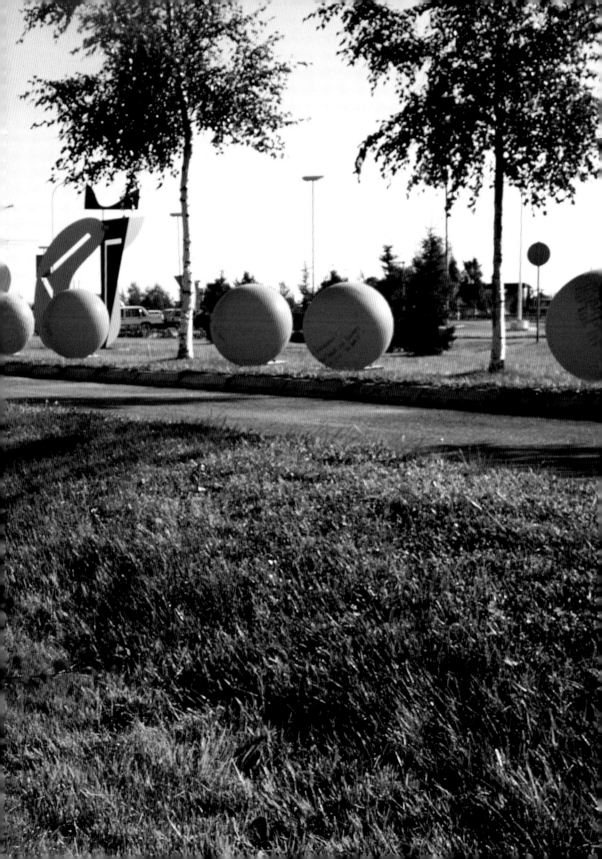

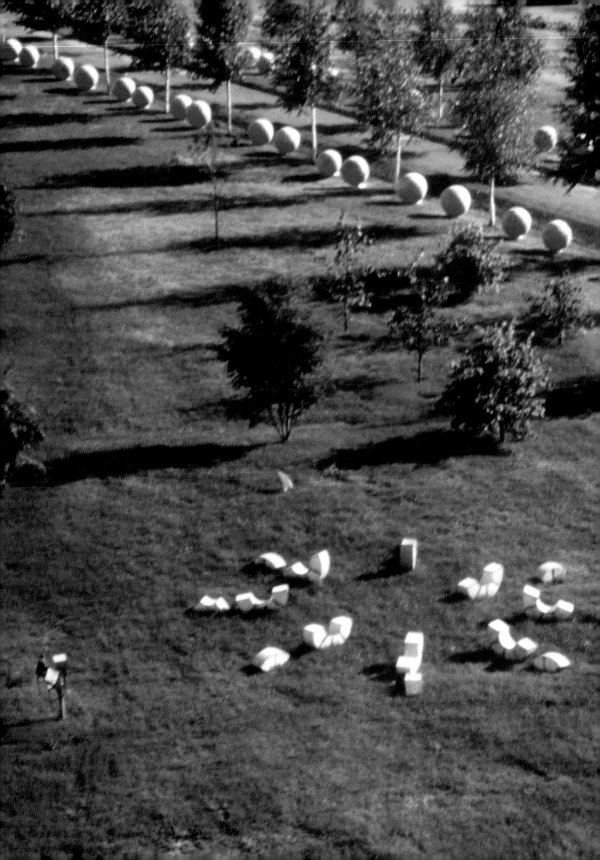

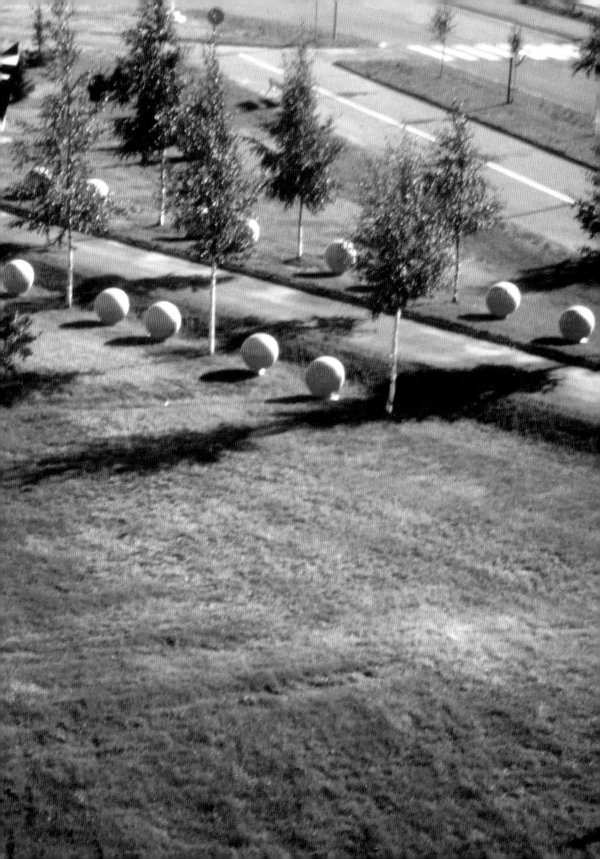

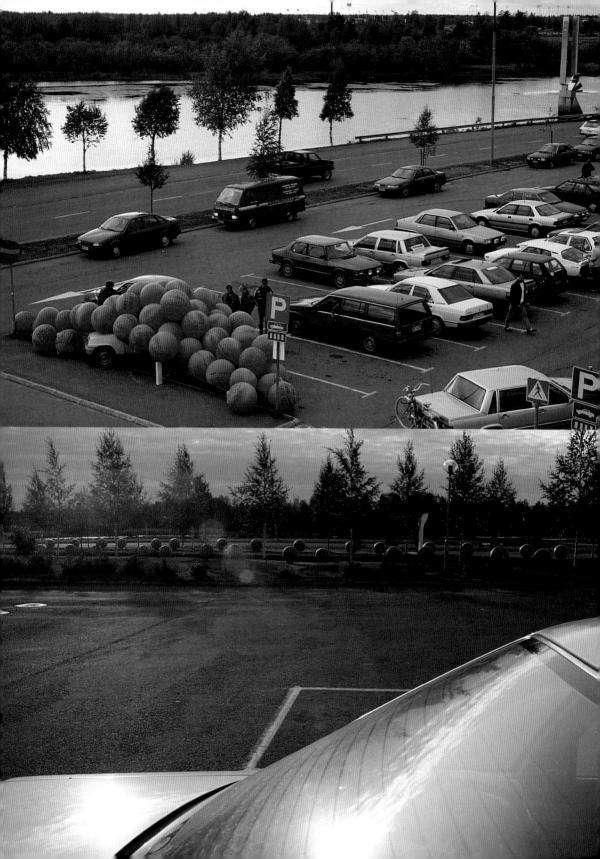

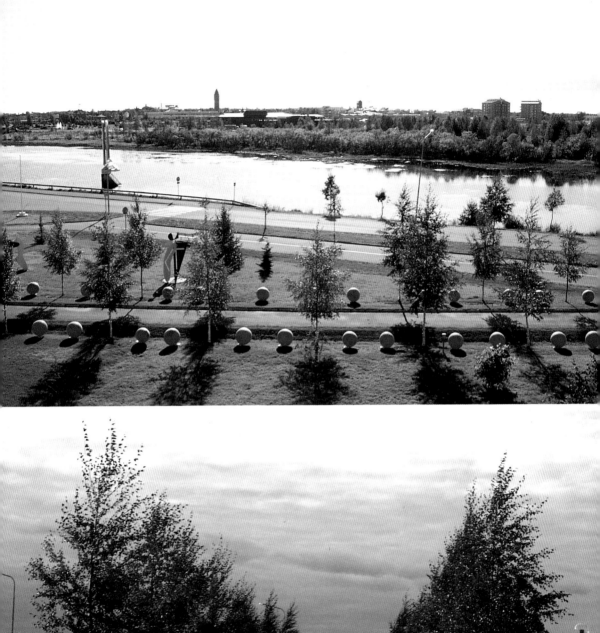

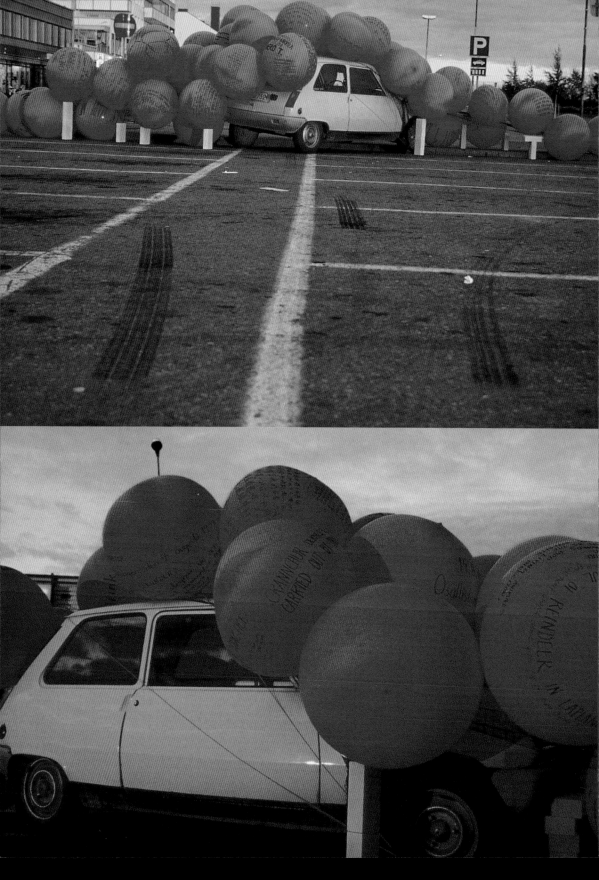

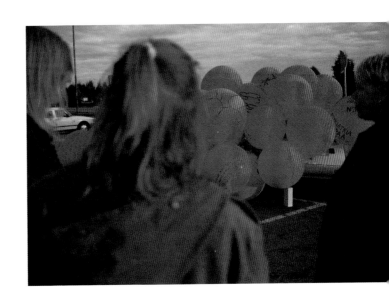

这件作品是瑞典托尼美术馆策划的一次主题为"Shaman"的艺术活动。Shaman是一种流传于北欧、俄罗斯北部、蒙古、我国东北地区的原始宗教形象。传说他具有神秘的力量，能预知未来并带给人健康。而七七四十九天则是在中国传统习俗中人死后的"七祭"。

This work was commissioned by the Tony Art Museum of Finland taking the motif of a 'shaman' which is a primitive religious figure known widely in northern Europe, northern Russia, Mongolia and Manchuria. It is said that a shaman has mystical power, can foresee the future and bring health to people. In traditional Chinese ceremonies, a 49-day period is the time required for the seven memorial ceremonies for the dead.

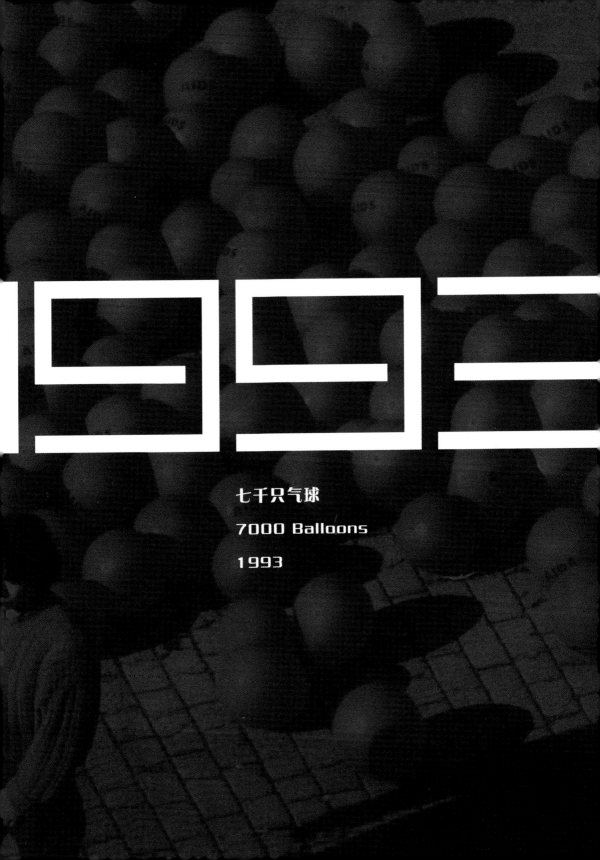

1993

七千只气球

7000 Balloons

1993

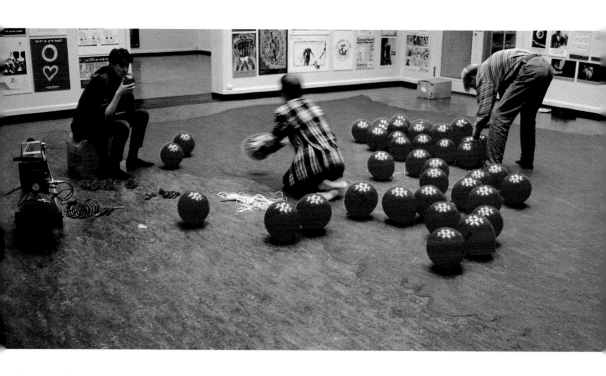

7000只气球被放置在挪威卑尔根市美术馆门前的广场上，每只气球上印着AIDS的字样。艺术家本人和他的表演合作者女舞蹈演员piavia被装在一个黑色的塑料袋子中和气球一起放置在广场上，随着围观的观众越来越多，米丘和piavia一起钻出袋子，在广场上进行了45分钟的行为艺术表演。表演结束后，大部分的气球被路过的孩子们带走。7000 balloons with word 'AIDS' were placed in the square before the Art Museum of Bergen in Norway. The artist himself and his assistant Piavia, an artist, were put into a black plastic sack and placed among the balloons. When the square was filled with a large audience, Mi Qiu and the other artist emerged from the sack and gave a 45-minute performance. After the performance, most balloons were taken away by passing children.

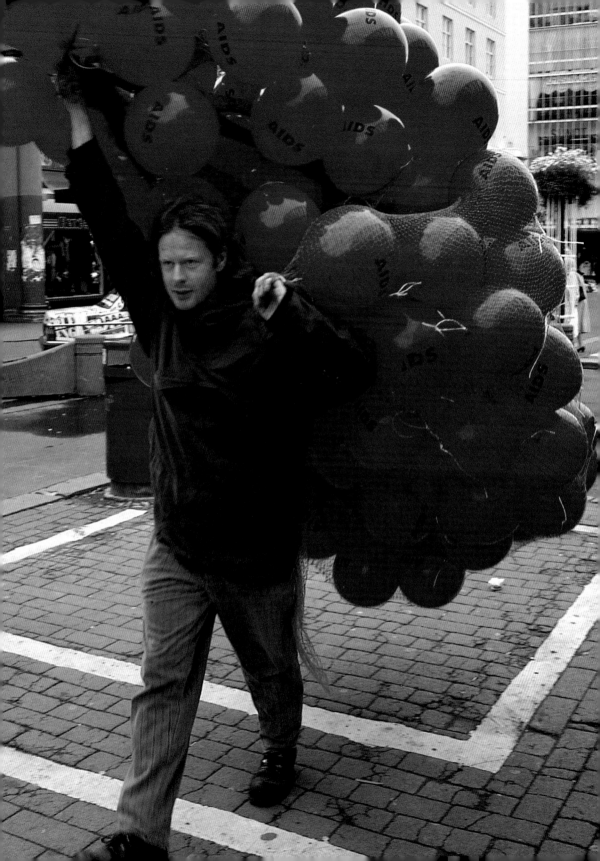

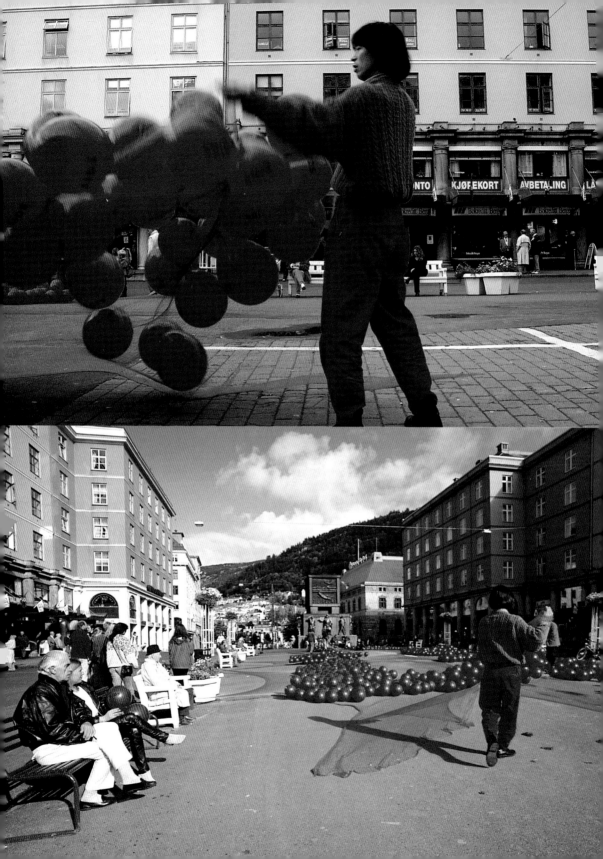

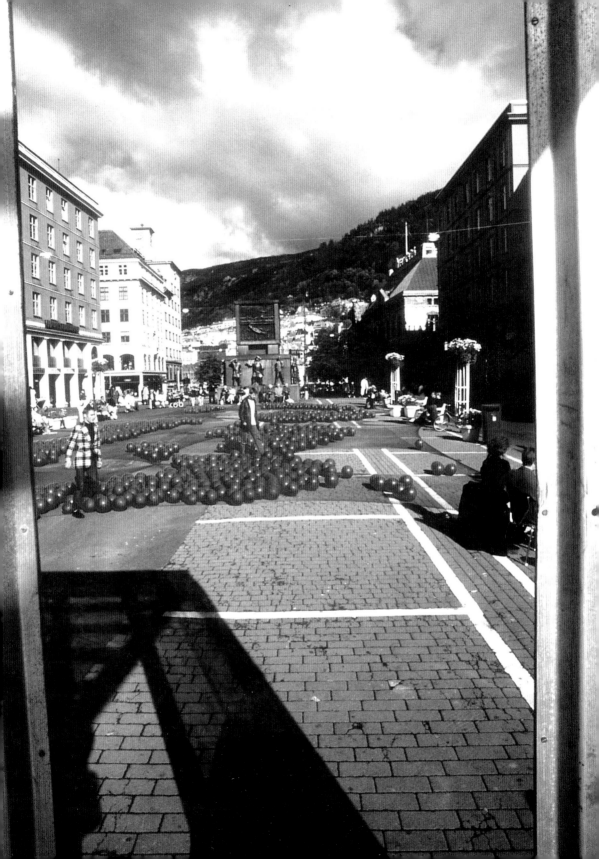

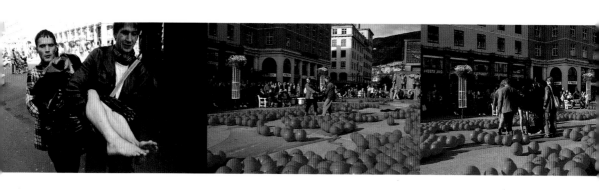

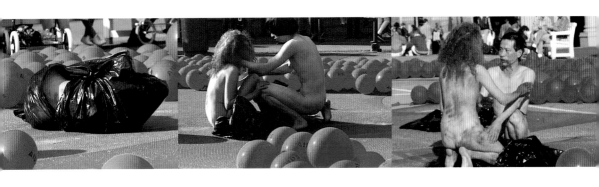

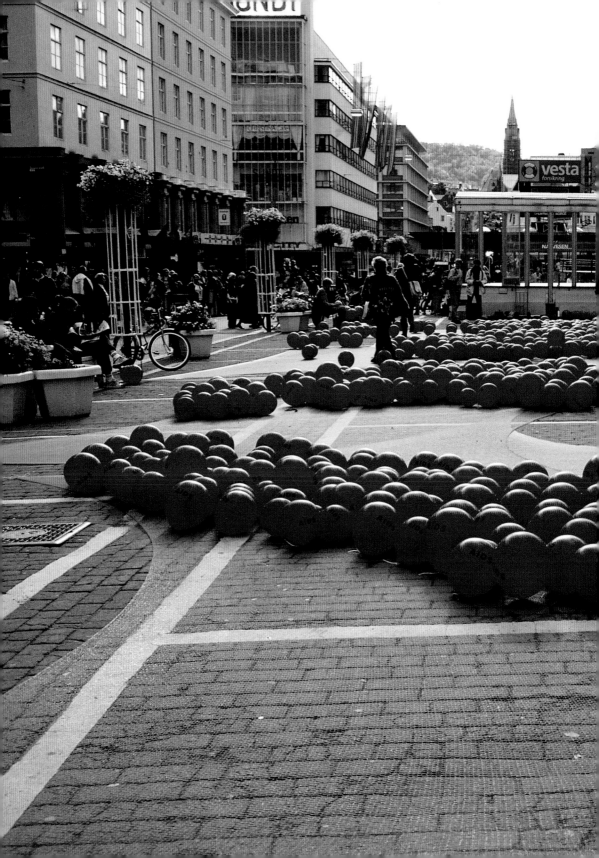

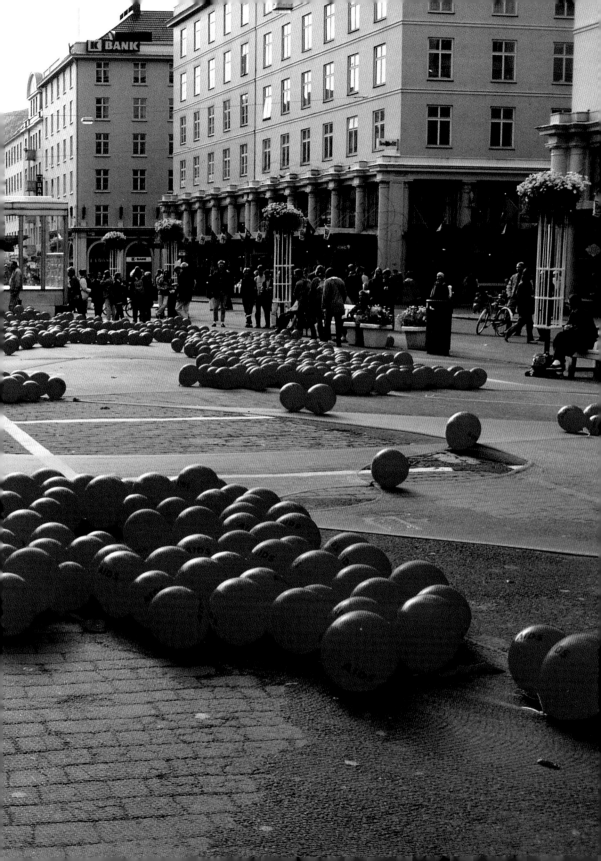

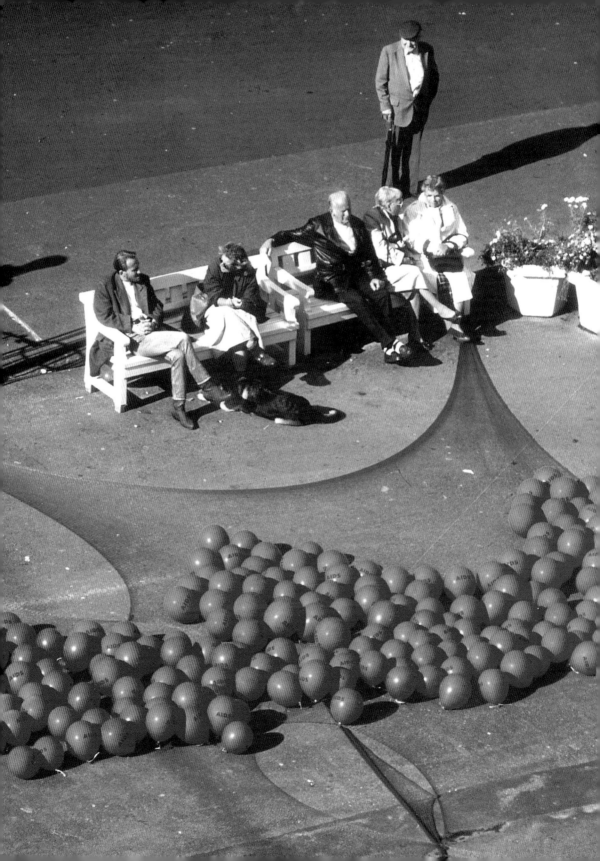

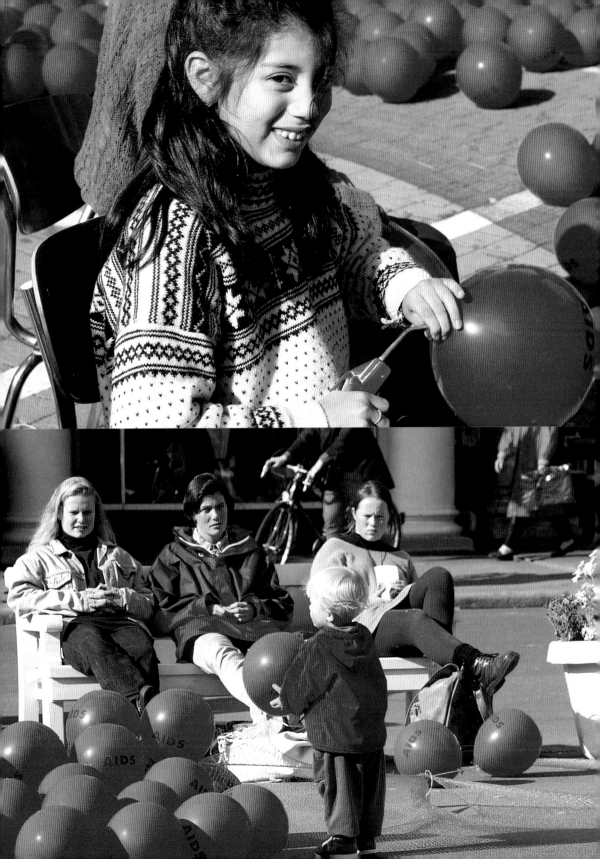

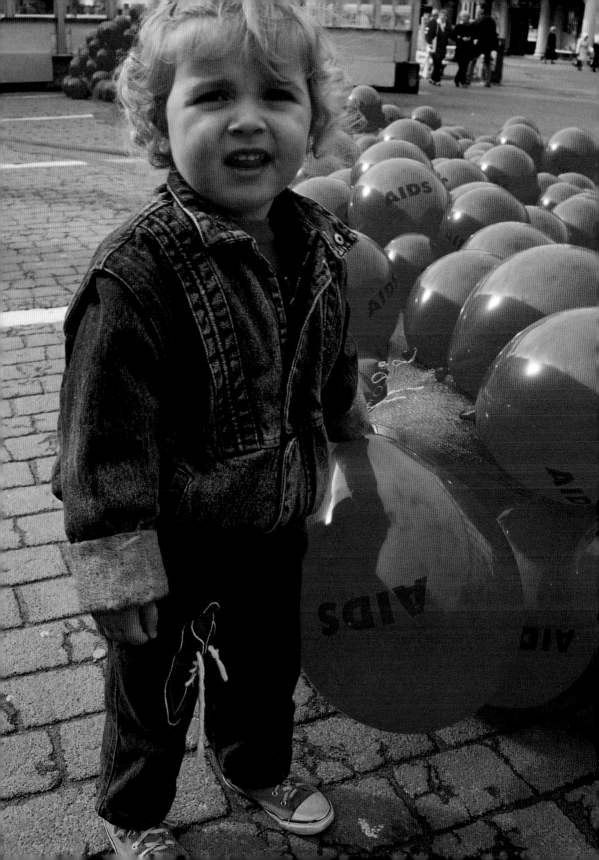

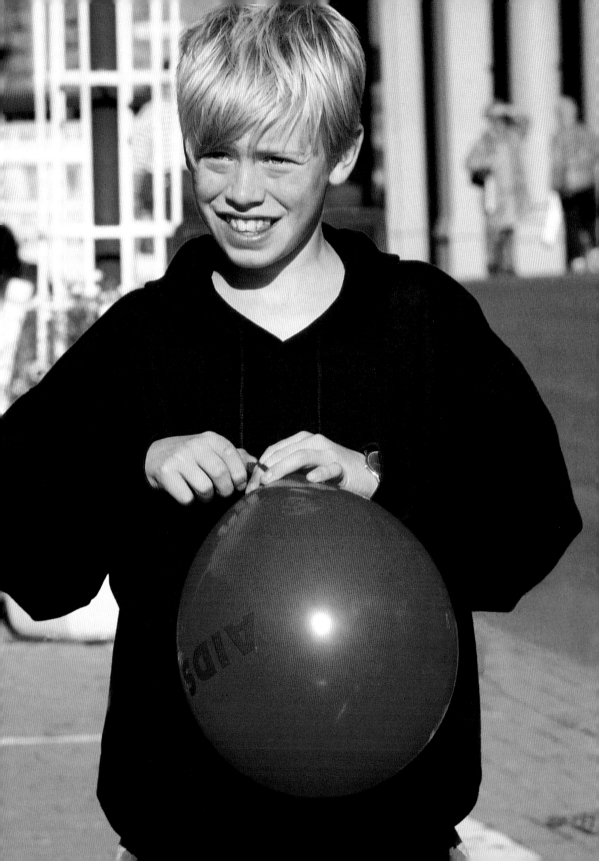

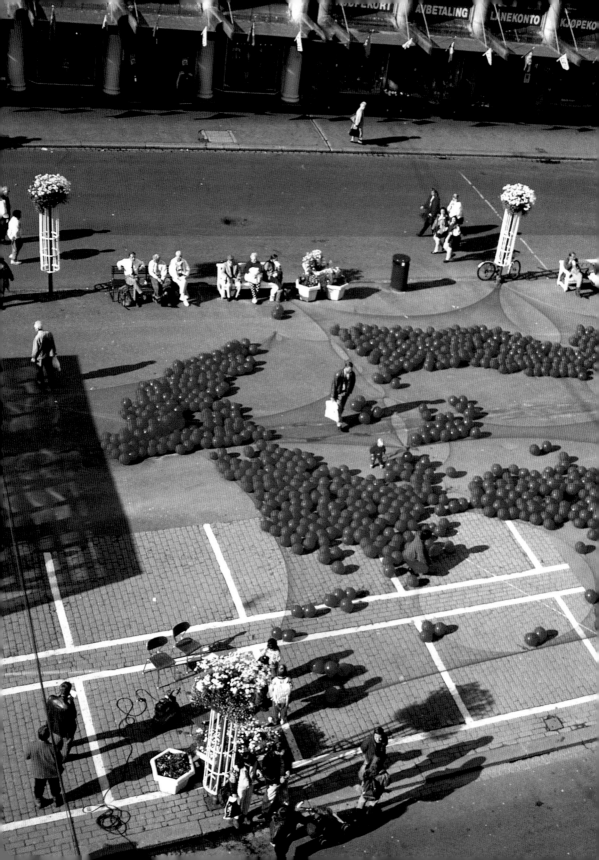

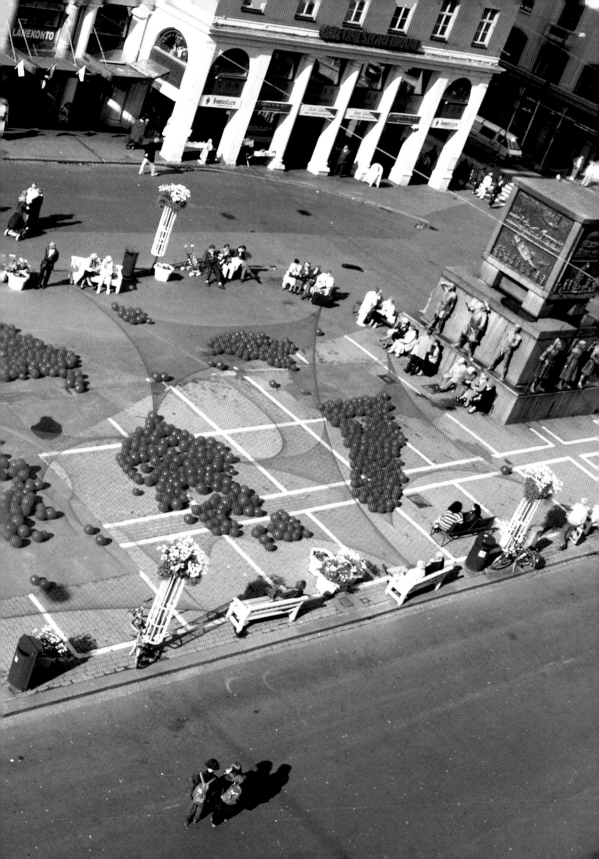

卑尔根市是易卜生的故乡,是一个相当保守的北欧城市,人们过着表面平和安逸的生活。《7000只气球》这件作品最有趣的部分在于艺术家的策划,红色的气球是当时麦当劳在欧洲一个推广活动中向儿童们赠送的礼品,孩子们欢天喜地的把米丘的气球也当作麦当劳气球带去了城市的各个角落,却不知道上面印刷的文字的含义。"AIDS"的字样和米丘裸体的行为艺术表演是对现代人普遍的冷漠态度的刺激和善意的警示。Bergen, the hometown of Henrik Ibsen, is a conservative northern European city where outwardly, people lead peaceful, comfortable lives. The highlight of the "7000 Balloons" was a unique concept: at that moment, McDonald's was holding a sales promotion in Europe, giving away red balloons to children. Therefore, children took Mi Qiu's balloons believing them to be gifts from McDonald's, unaware of the meaning of the words written on them. The word 'AIDS', as well as Mi Qiu's performance in the nude were a provocation and concerned warning to modern people against possible indifference to social problems.

1993

纸牌游戏

Playing a Card Game

1993

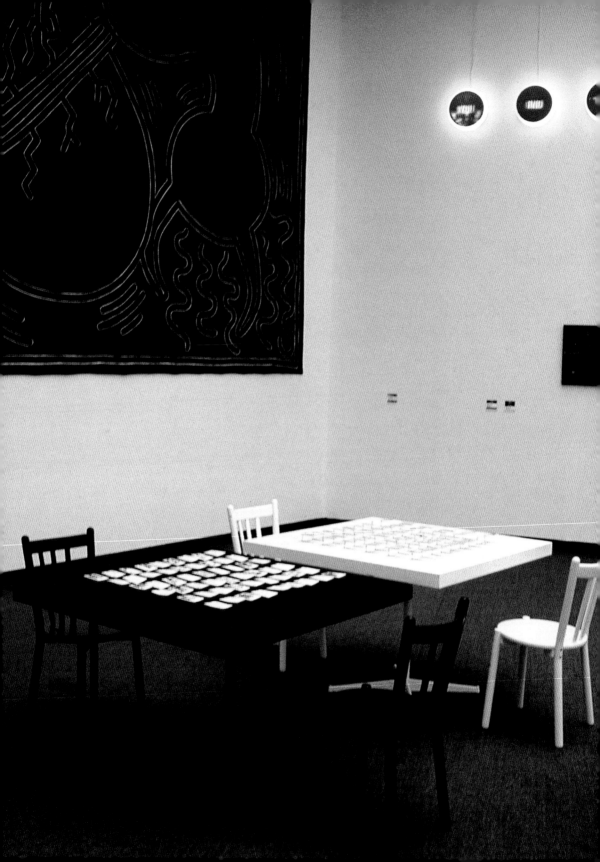

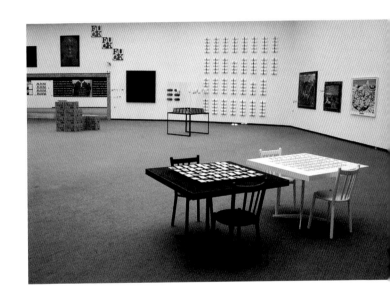

两张1.3米×1.3米的桌子和四把椅子，分别被漆成白色和黑色，两副纸牌悬空摆在桌上，白色的桌上的牌全部是反面，桌面上印着54个死于非命的艺术家的名字组合，黑色的桌上的牌全部是正面，牌上印着这54位艺术家的头像。Two sets of tables 130 cm square, and four chairs were painted white and black respectively, with a set of playing cards suspended above each one. Above the white table, the cards, their backs facing upwards, were printed with name of 54 artists who had died an unnatural death; above the black, with the in their faces pointing upward's, were printed the 54 corresponding portraits.

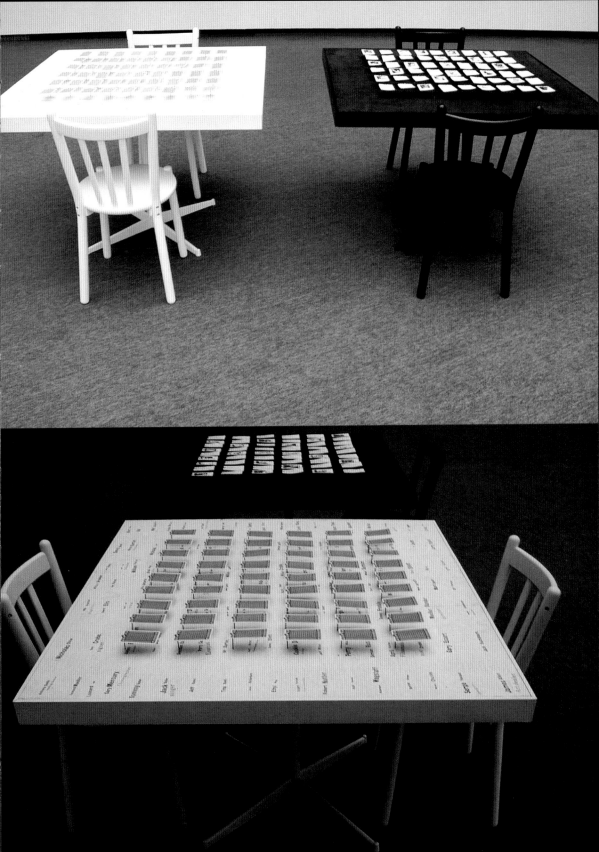

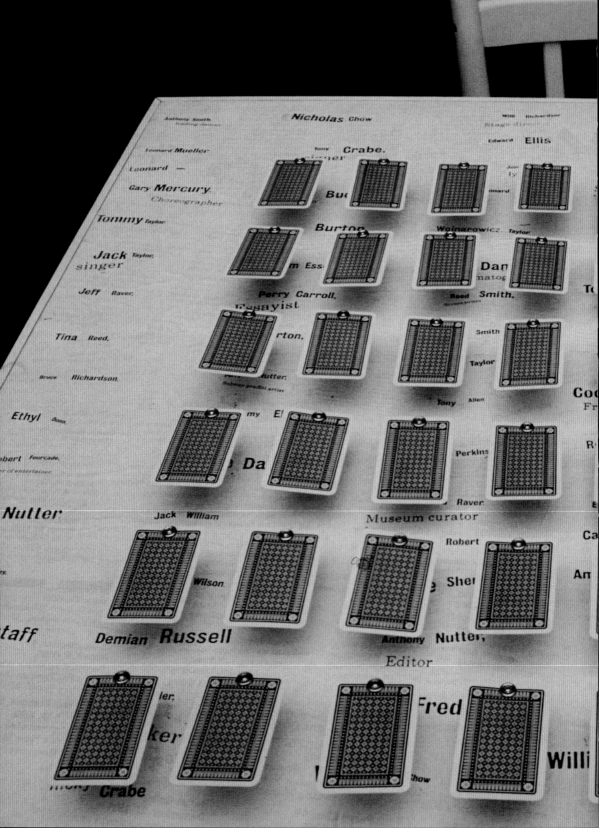

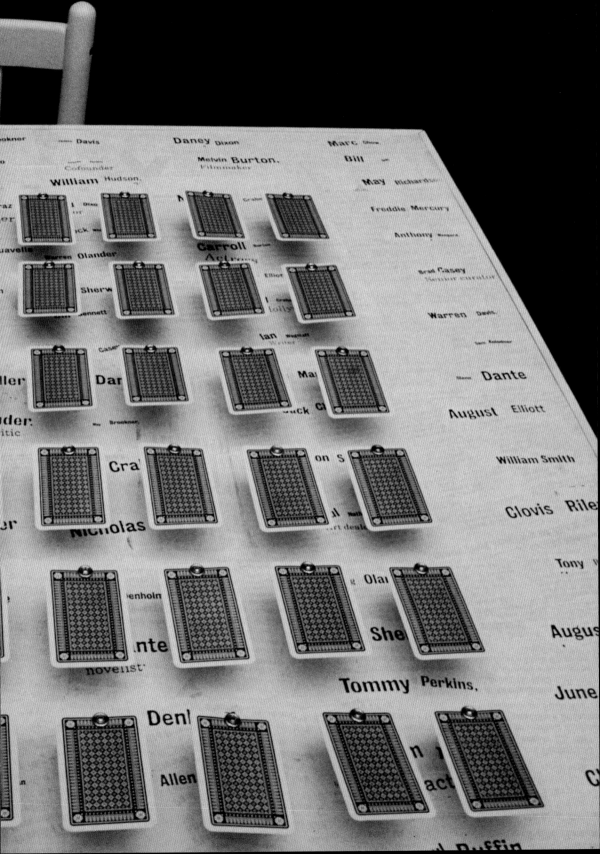

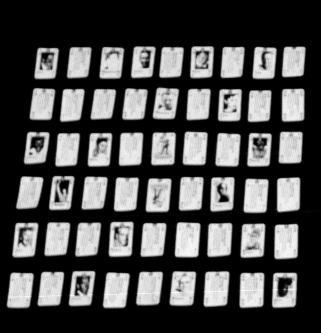

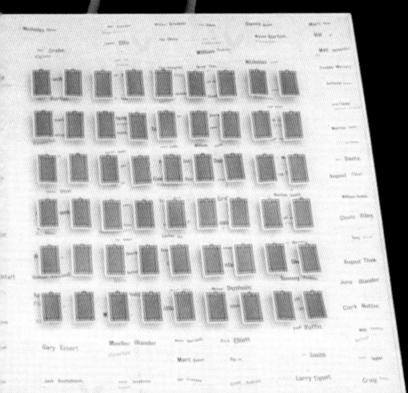

游戏是人类永远热爱的活动，它也最接近艺术和宗教，冥冥中不可知的力量操纵着胜负生死，这件作品表达了艺术家对于这种跨越现实世界与神秘世界的奇异力量的关注与诠释。Games are activities that people enjoy greatly, and which are closely related to art and religion. In the unseen world, unknowable power controls victory and defeat, life and death. This work shows the artist's concern for and annotation to the preternatural strength spanning the real and the unseen world.

1993

再现艺术

Reproduction of Art

1993

在米丘自己的展览布展时，他突然决定将美术馆原有长期陈列的艺术品全部用布包起来，但保留标签在外面，以此作为自己展览的作品而取消原有的展览计划。While arranging his solo show, all of a sudden Mi Qiu decided to wrap up the artworks at the art gallery with fabric, leaving only the labels outside, replacing the existing exhibits with the new ones.

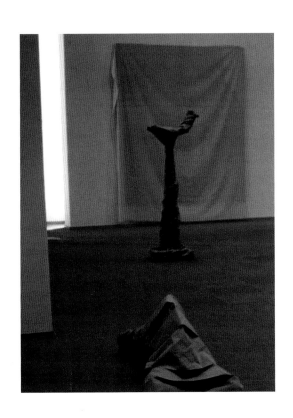

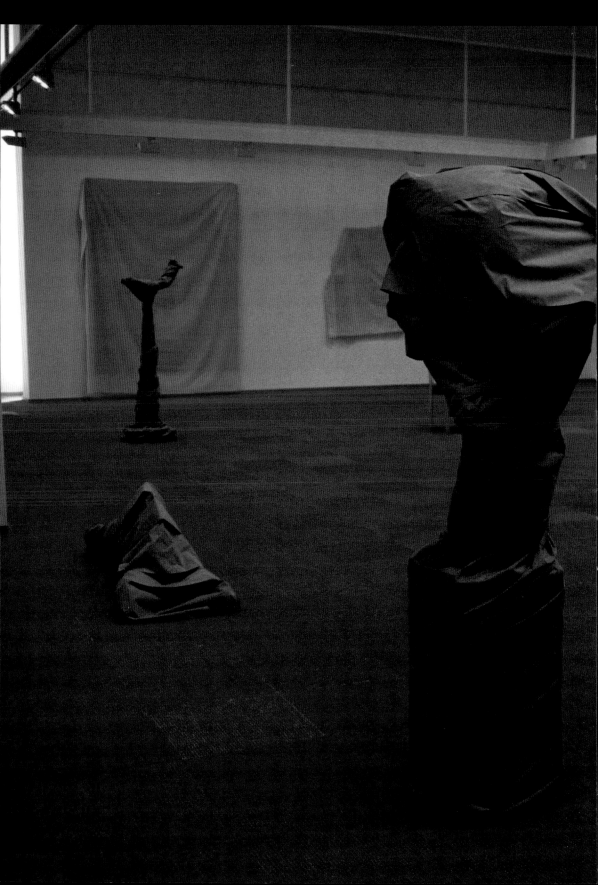

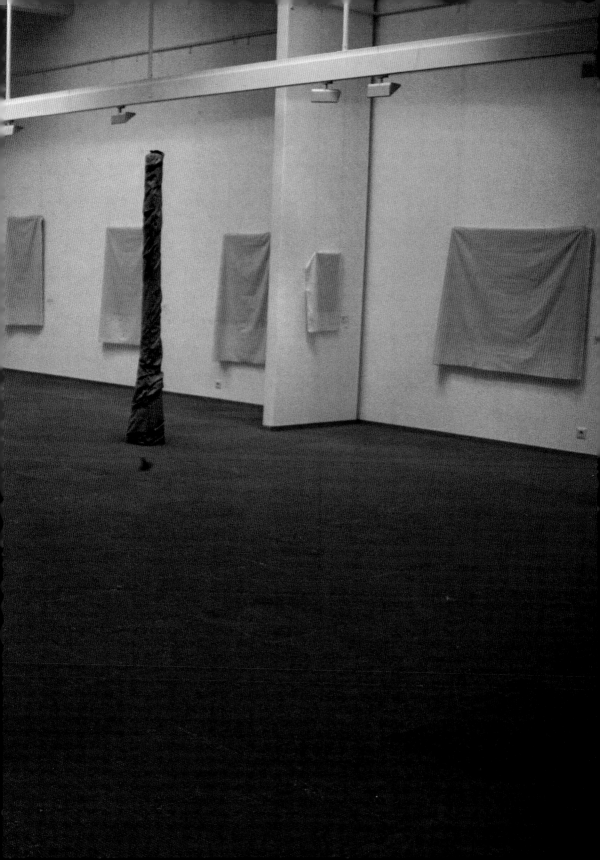

这件偶发的作品尽管米丘在国内从未发表过，但具有米丘其他作品中少有的幽默感，与美术馆和观众都开了一个玩笑——米丘的作品不完全是沉重的。This unusual work, although never announced by Mi Qiu internally, carries a sense of humour not found in his other works. He played a joke on the art gallery and the audience as well -- Not all his works are oppressive.

1996

中国艺术5000年

5000 Years of Chinese Art

1996

在《〈中国艺术5000年〉》展览的布置上，米丘使用了大量现代装置和室内空间设计的概念，首先将36吨黄土从黄河运到欧洲，铺在展厅里，然后大量地使用玻璃和金属，使所有古代的文物都悬空地搁置，灯光从上下两个方向打向作品，制造了一种眩目、空旷的视觉效果。观众穿行其间，有着与传统文物展览截然不同的观感。Mi Qiu used a great deal of contemporary installation and special planning to produce the large project '5000 years of Chinese Art'. He took 36 tons of yellow earth from the Yellow River and transported it to Europe to use as the ground in the exhibition hall. Then, with glass and metal, he produced reproductions of ancient relics which were suspended in the air, light shining on the works from two directions. This produced an effect of brightness and spaciousness. Moving through it, the audience had a completely different impression from thet of a traditional show of relics.

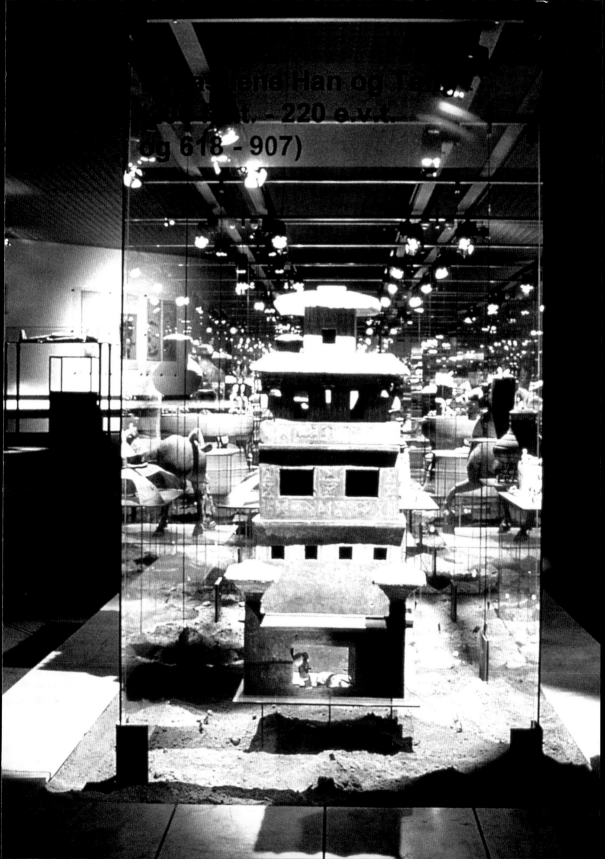

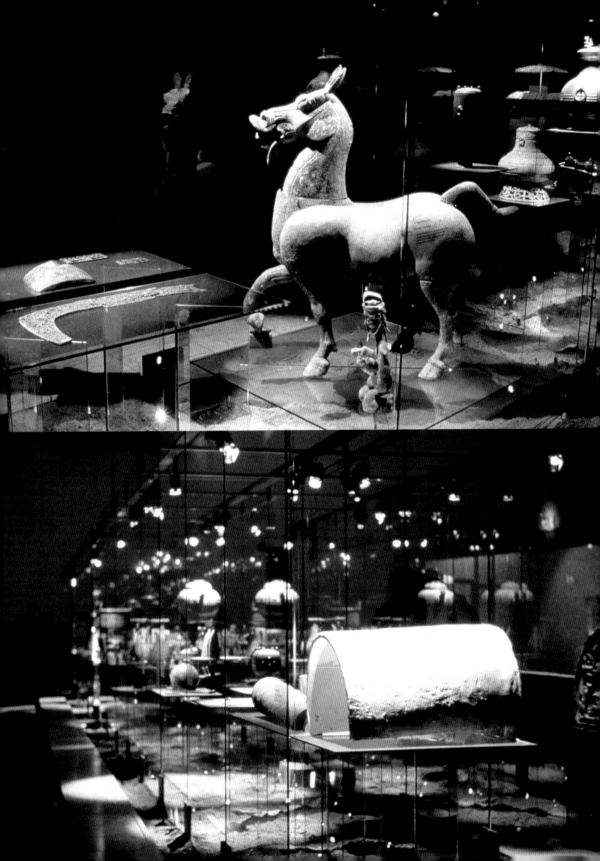

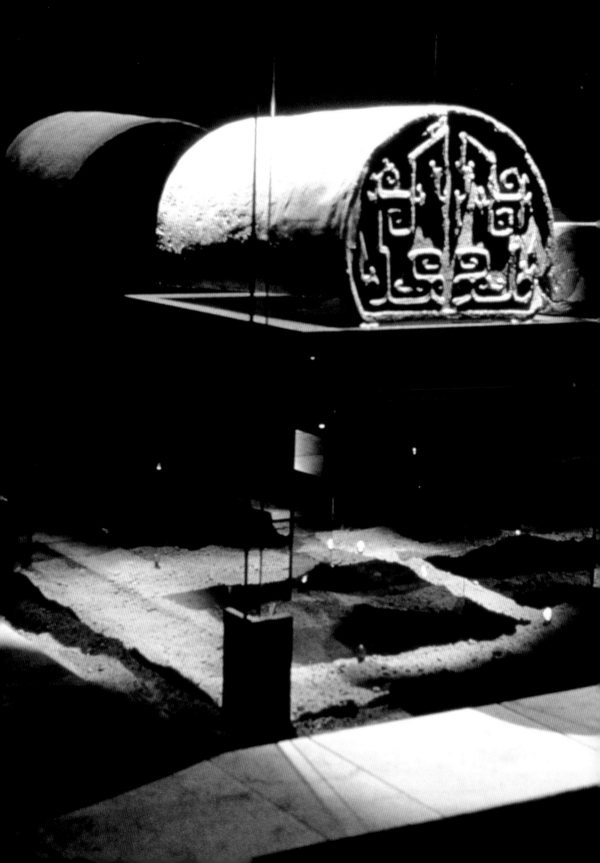

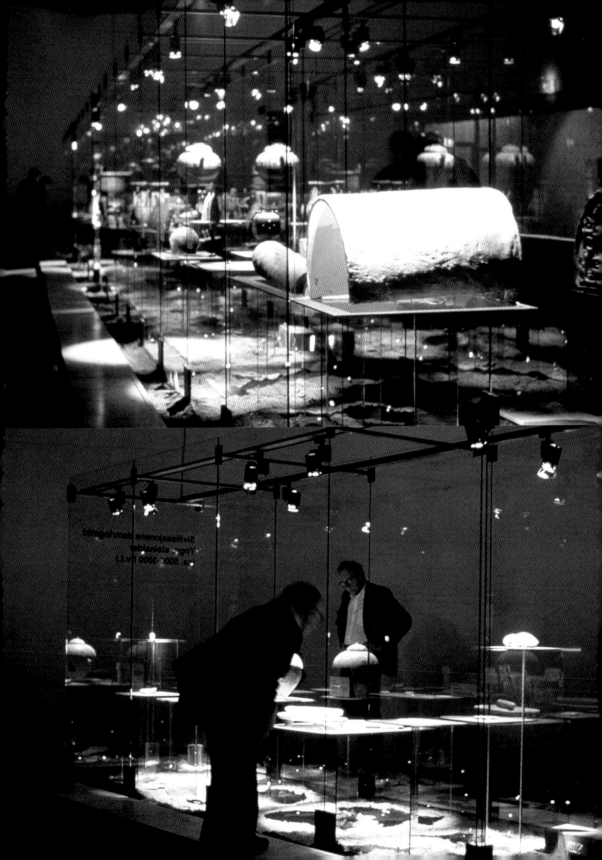

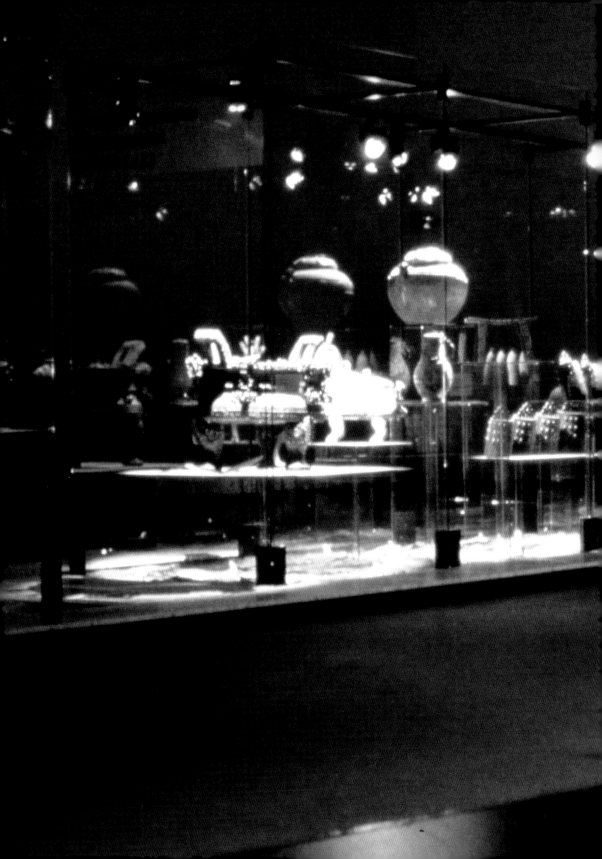

如果将这个展览的装置设计当作一件作品的话，那么200件中国的一级文物也不过是整个作品中的一个元素而已，它们与36吨黄土和玻璃、金属、灯光共同构成了一个鲜活、立体、完整的中国文化灿烂景观。If this whole project is considered as one work, the 200 Chinese rare relics are no more than one element. Together with the 36 tons of yellow earth, the glass and metals and the lighting combined to form a lively, three-dimensional and integrated scene of Chinese culture.

媒体的干预

Media Intervention

1998

在一面由36个电视机组成的电视墙上，米丘本人的面部形象以不同的角度出现在各个电视机中，反复述说着关于全球媒体日益冷漠和庸俗化的话题。On a TV-wall composed of 36 television monitors, the image of Mi Qiu's face was projected from different angles, as he repeated statements on the topic of the increasing lack of concern for, and philistinism within, the global media.

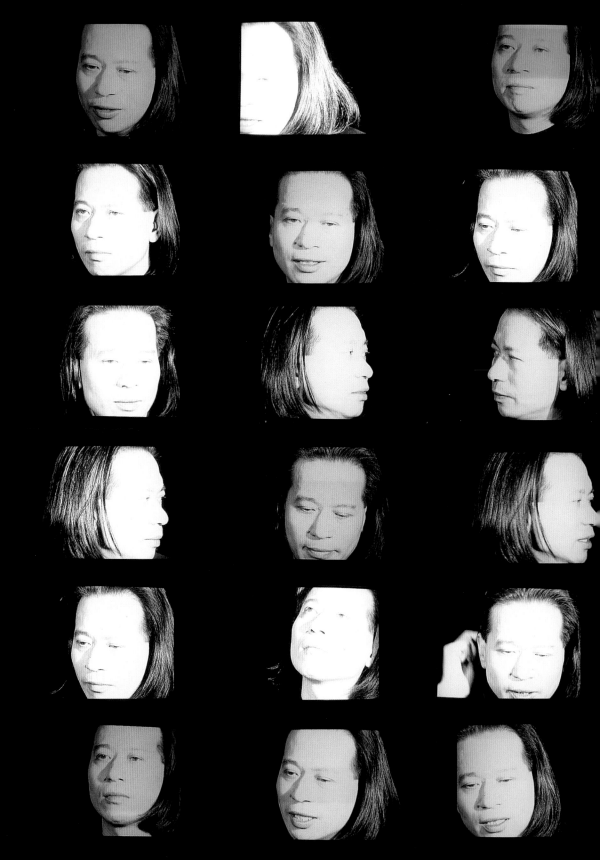

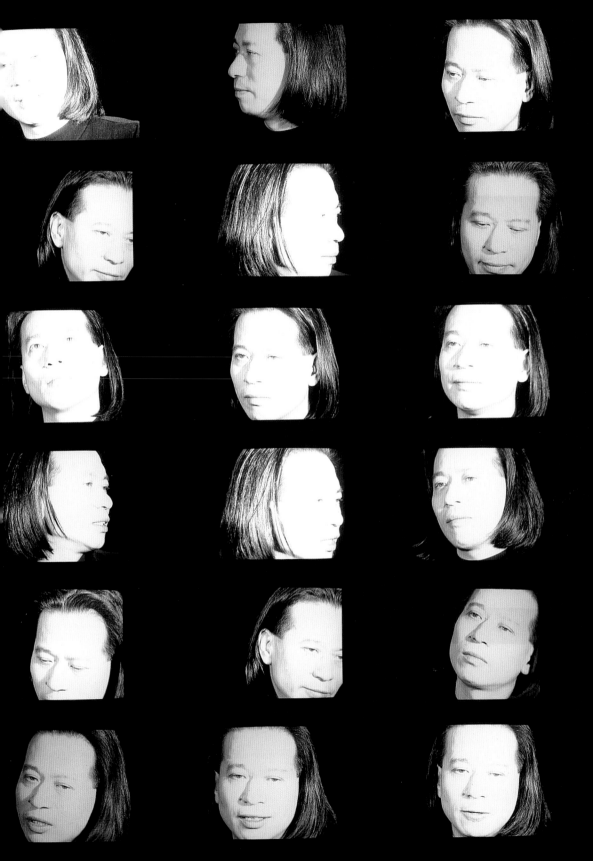

VEDIO的力量总是很直接的，加上电视墙所造成的压迫感，制造了一种奇怪的效果，艺术家的声音在此时此地压倒了传媒的声音，但这只能是一种艺术的反讽和抗议。The direct strength of video, in conjunction with the sense of pressure created by the TV wall produced a strange effect. The voice of the artist overwhelmed that of the media, which was the artist's irony and protest.

幸福·生存　系列1

Divine Existence 1

1999

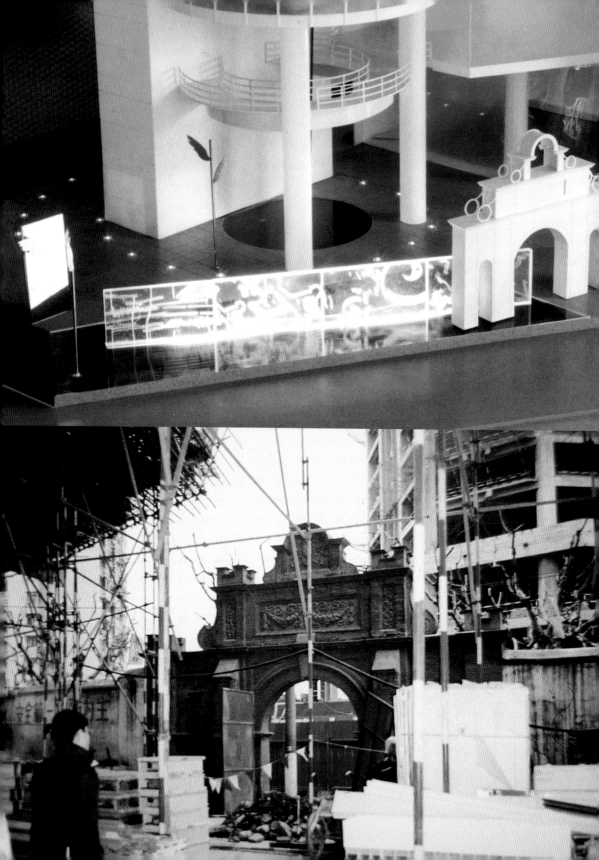

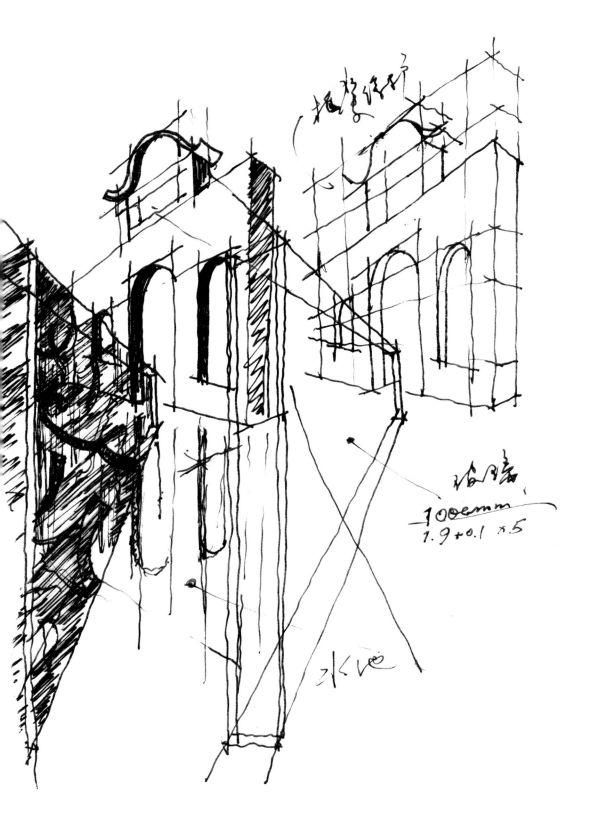

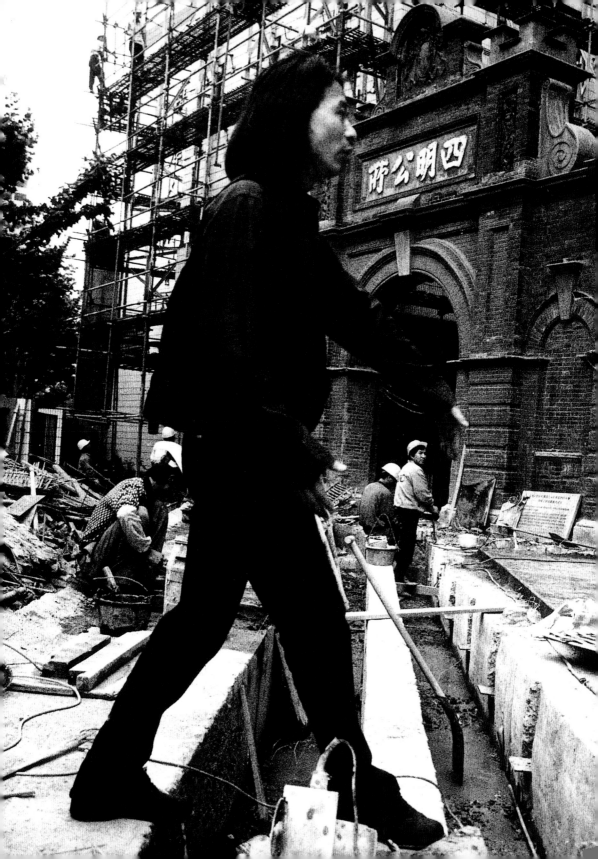

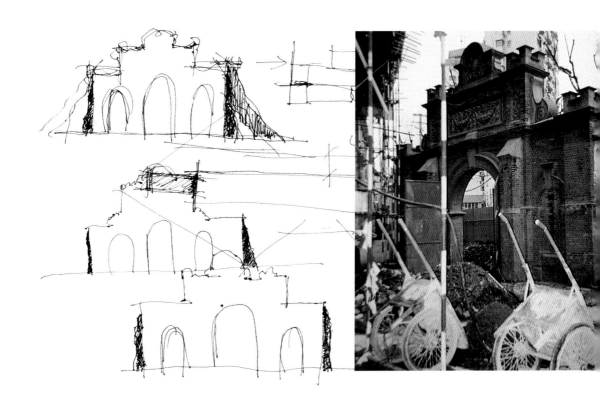

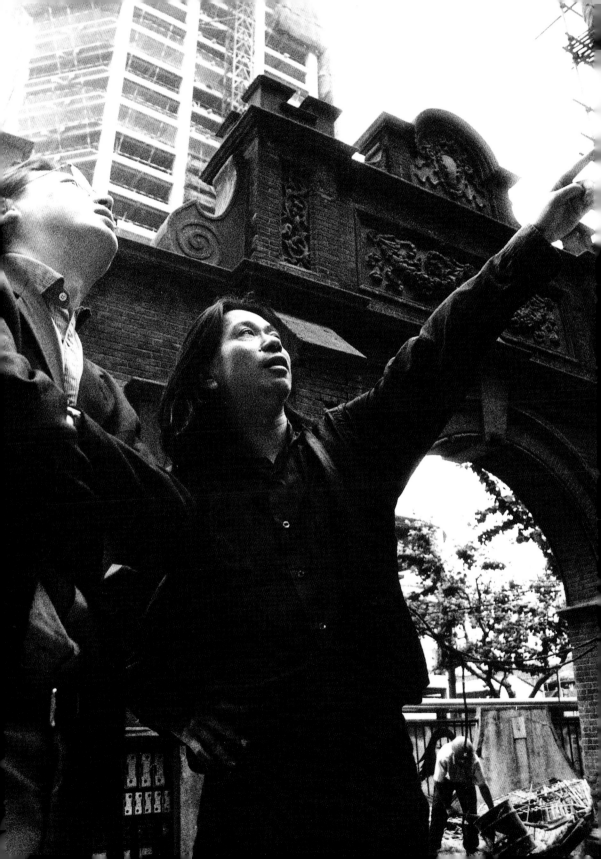

在上海宁寿大厦的环境设计中，米丘将大厦门前一个在规划中可以拆除的清代牌坊四明公所整体平移了26米加以保护，作为整体建筑环境艺术的一部分。在牌坊与大厦的中间竖立了一块长18米，高2.4米，厚10厘米的玻璃，玻璃上有艺术家本人绘制的抽象图案。同时在户外的环境中树立了5件单体雕塑作品。In the environmental design of Shanghai's Ningshou building, Mi Qiu worked with an old chastity arch from the Qing Dynasty which stood in front of the building. The arch had been designated for demolition. The arch was moved 26 metres and between it and the building was placed a piece of glass 18 metres wide and 2.4 metres tall, 10 cm thick, on which Mi Qiu painted abstract motifs. The relocation was done in line with city planning guidelines and the result of Mi Qiu's intervention meant that not only was the arch retained but made a focal point of the environment.

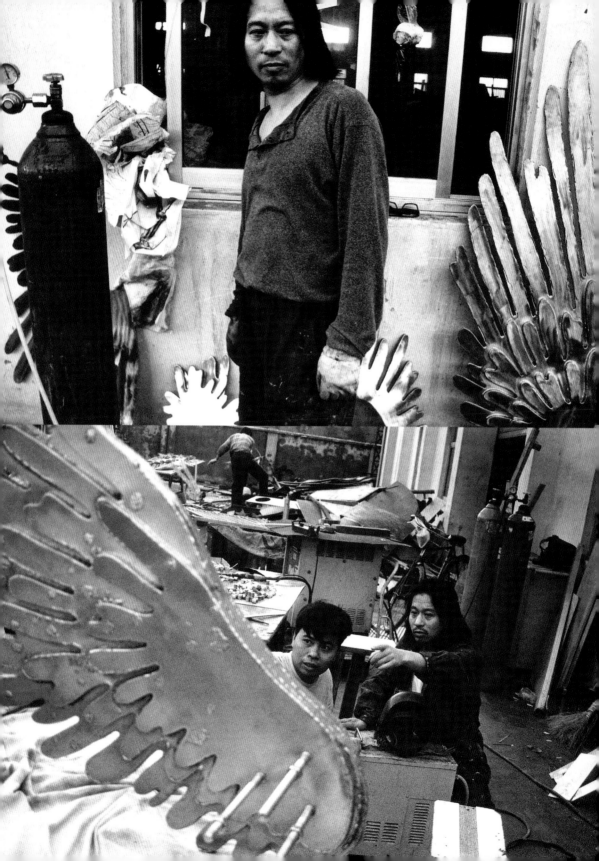

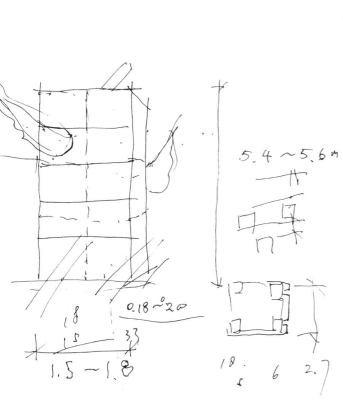

5.4 ～ 5.6 m

0.18 ～ 20

1.5 ～ 1.8

18.5　6　2.7

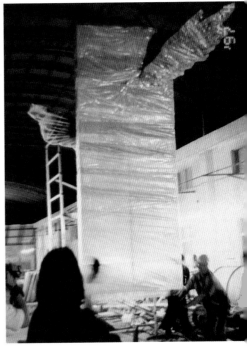

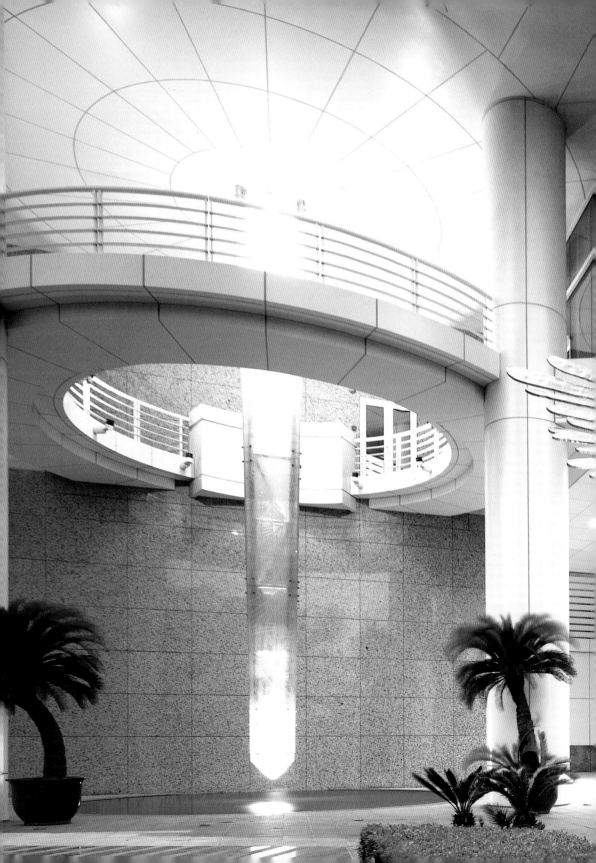

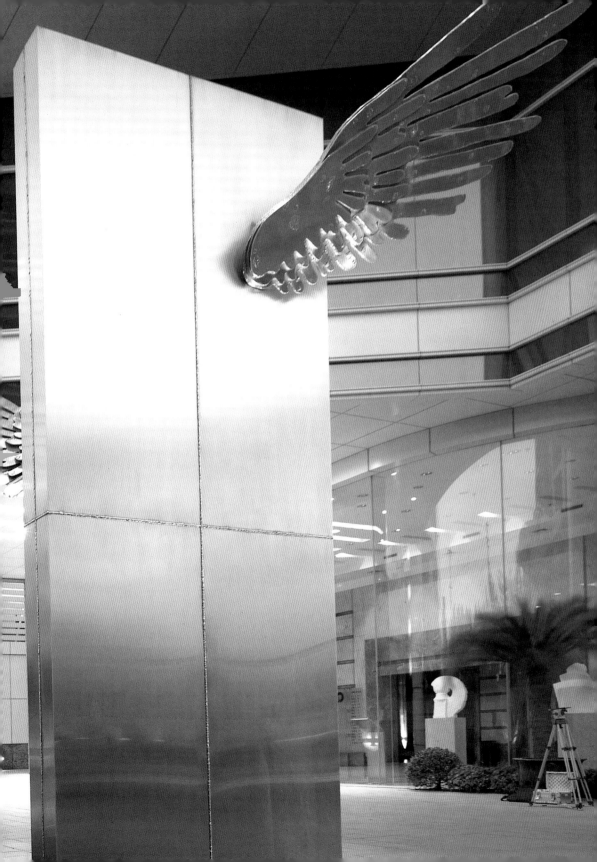

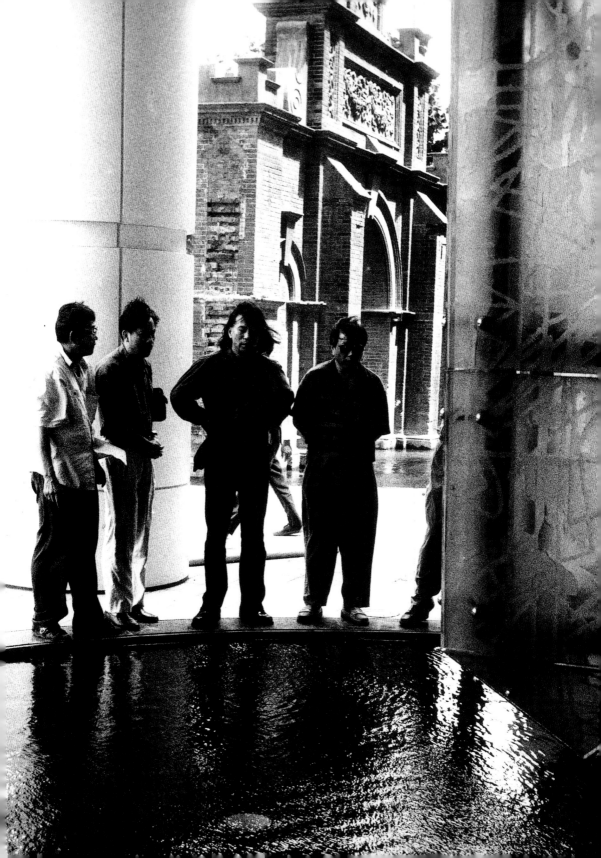

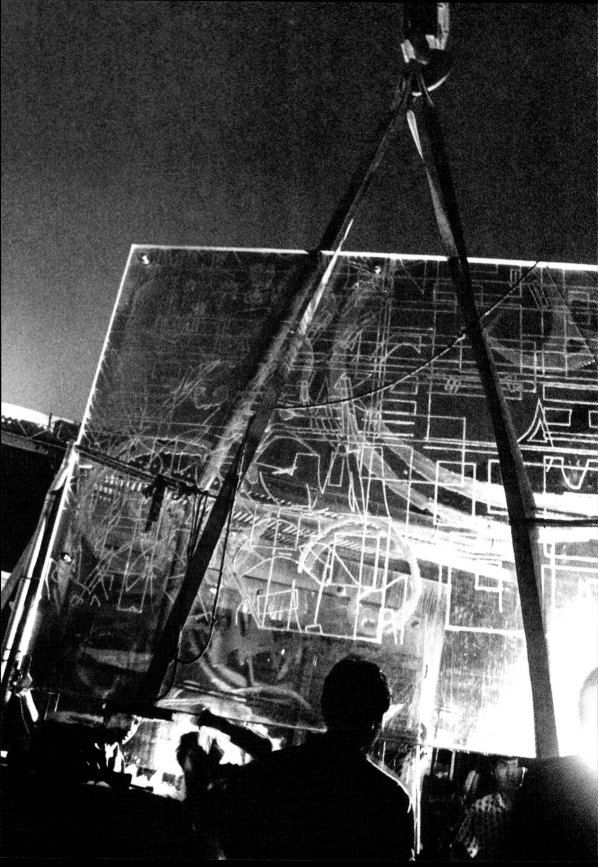

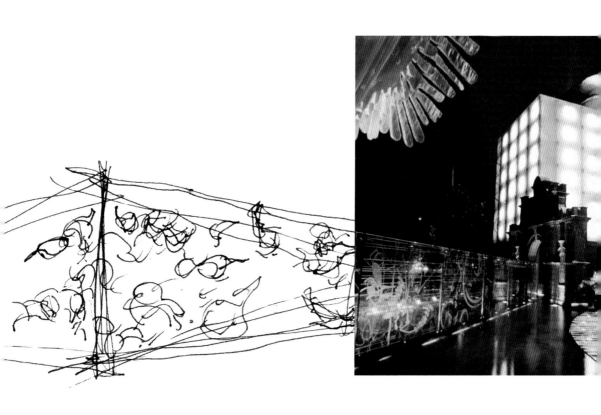

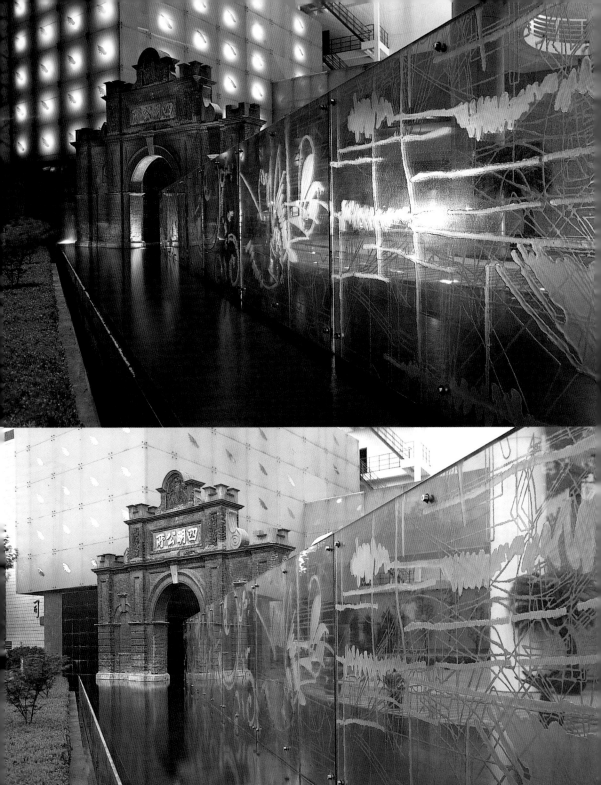

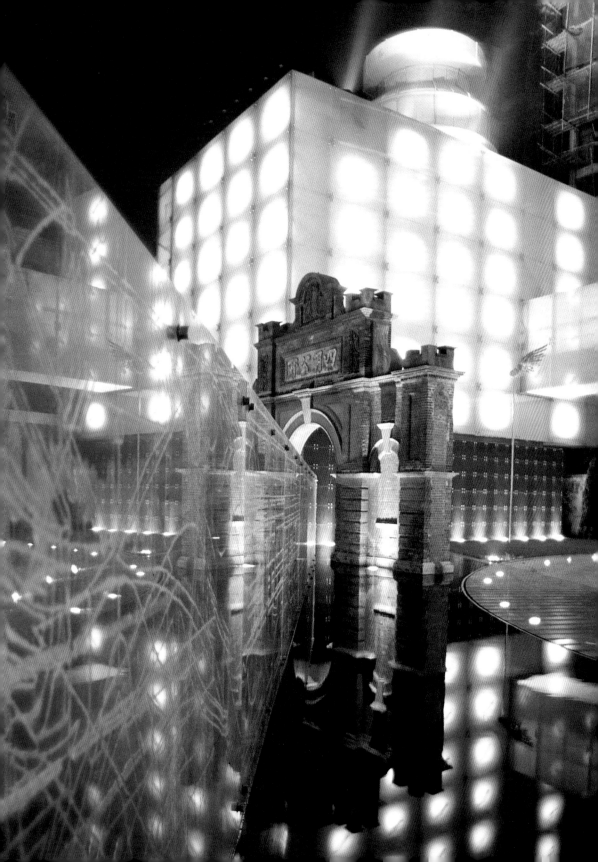

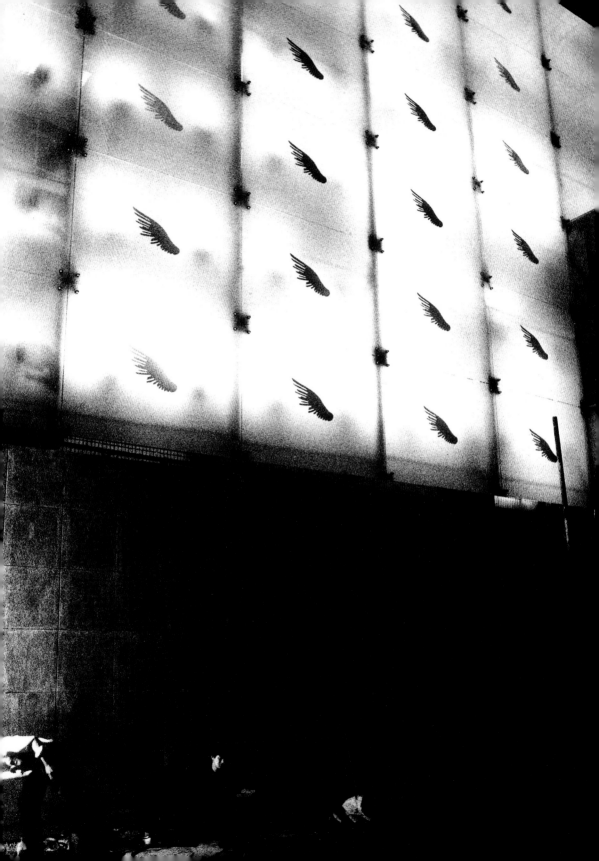

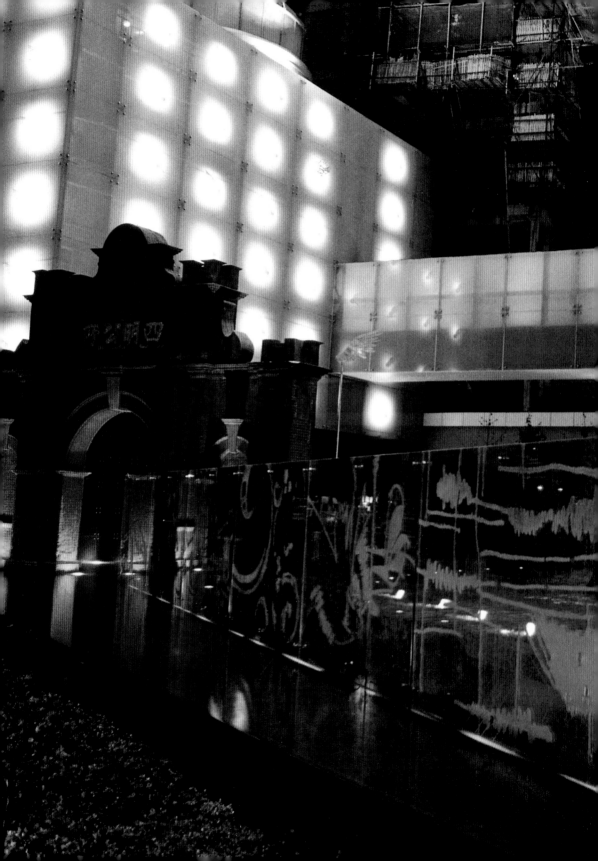

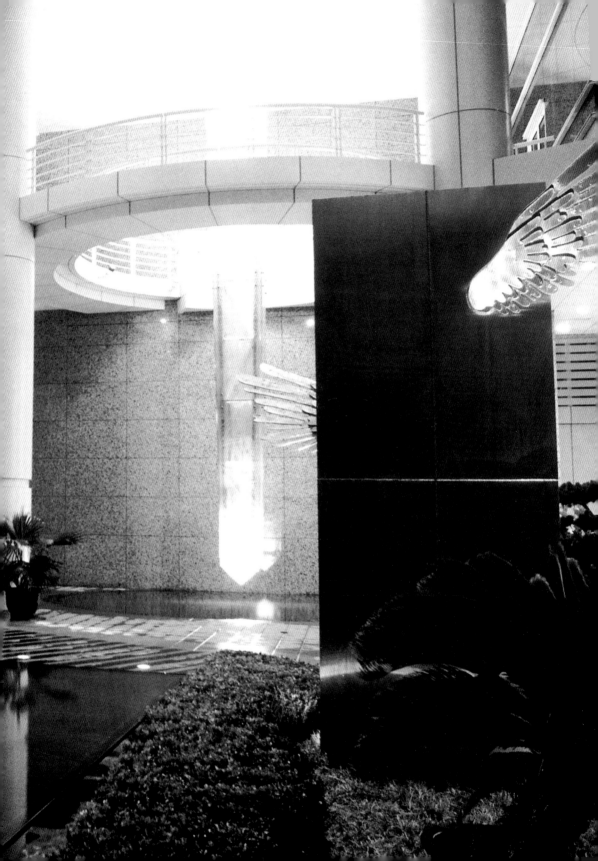

从这件作品开始，米丘提出了"ArTech"的概念，新艺术的产生永远是与新技术的应用相伴的，平移四明公所牌坊是一个绝妙的想法，但必须有严谨科学的施工方案支持，结合了先进技术力量的艺术作品是有力量的，同样结合了艺术也给冷冰冰的技术提供了丰富的人性的内涵。这一作品是在城市空间上以历史、建筑、生态和未来作为背景的环境创作，也是从这个作品开始，米丘将飞翔的翅膀这个符号运用到他的一系列公共艺术作品中，这个符号在米丘的作品中象征了梦想、幸福和所有美好的事物。The project inspired Mi Qiu to put forward the concept of 'ArTech'. This is created with the application of new technology. To move such an arch required technical knowledge. Artworks that used advanced technology are powerful and yet inject technology itself with the warmth of the human spirit. This work is an environmental product related to an urban space and connected to history, architecture, ecology and the future. It was from this work that Mi Qiu began to use the motif of the flying wings in his public art works. For him this is the symbol of dreaming, of happiness and goodness in life.

1995

幸福・生存 系列 2

Divine Existence 2

1999

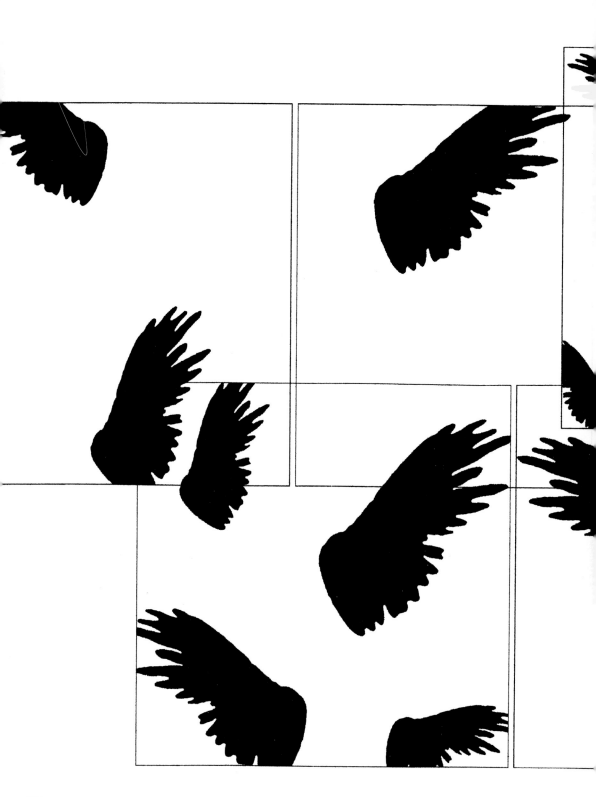

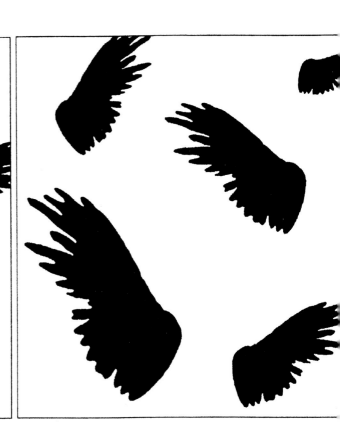

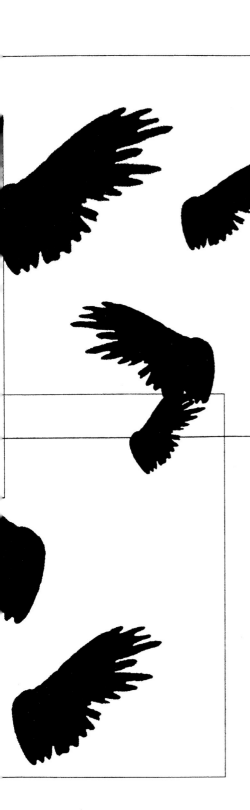

两件1000微米X1000微米的高纯度水晶制作成骰子的形状，一件为白水晶，一件为黑水晶，内嵌24K纯金的翅膀。该作品获得世界黄金协会千禧大奖。Mi Qiu made two dice one cubic metre in size out of two pieces of high purity crystal. One white and one black. Both were inlaid with 24-carat gold wings. This work was awarded the Millennium Prize by the World Gold Association.

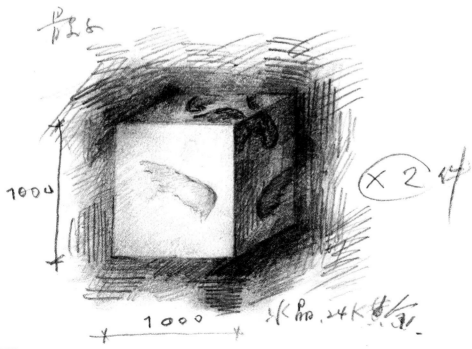

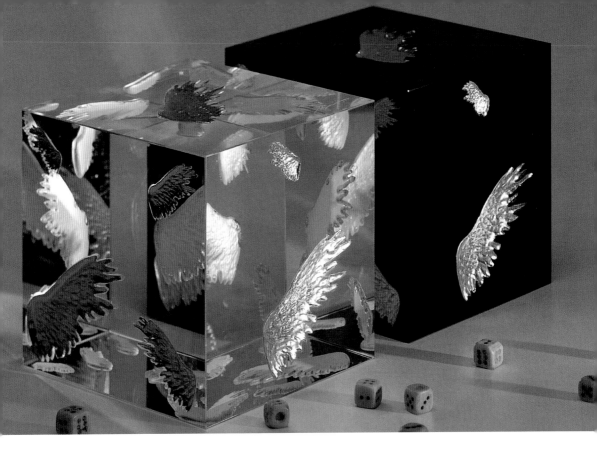

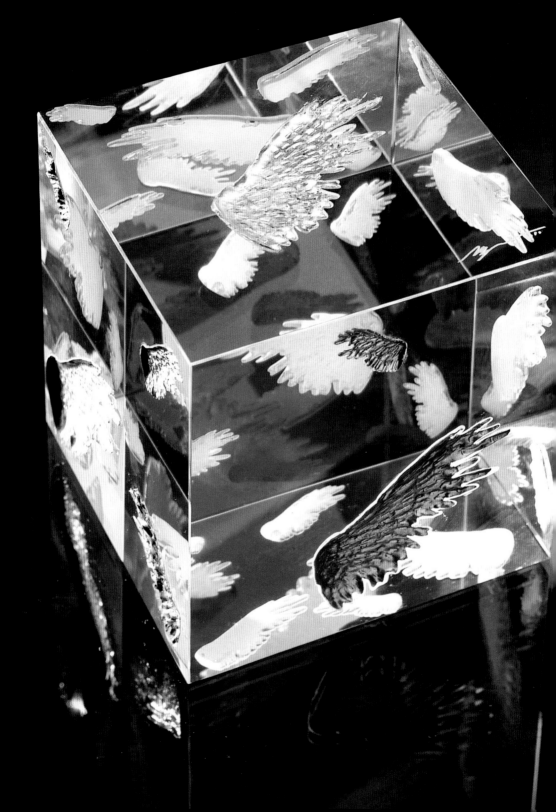

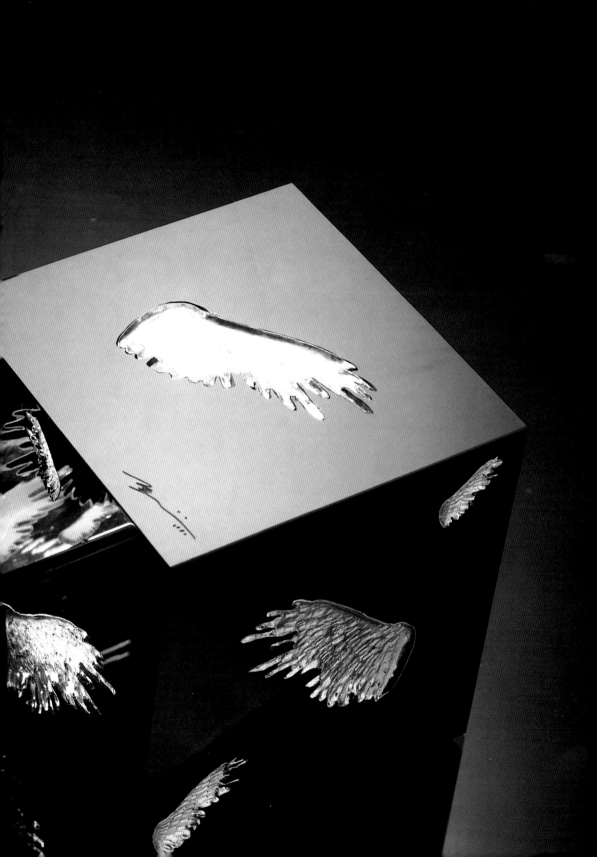

这件作品在米丘原有"游戏"作品系列的概念中加进了"ArTech"的技术因素，将水晶和黄金两种材质完美地结合在一起，用晶莹透彻的水晶和象征幸福生存的金色翅膀转化了决定胜负命运的骰子的概念。同时在千年交替的时刻用艺术作品表达了对于人类未来的良好祝愿。The piece combines the former concept of the 'game' series with the 'ArTech', perfectly integrating crystal with gold. The glittering and translucent crystals, and the golden wings signify the happiness of change, although the dice imply change can mean gain or loss. At the turn of the Millennium, the artwork was meant to express Mi Qiu's wish for the happy future of mankind.

1999

深圳雕塑公园

Sculpture Park in Shenzhen

1999

长80米的水上玻璃桥，观众可以在其上行走，玻璃上用电脑数码的方式铭刻着艺术家关于人类生存和未来的文字描述。同时在周围的空地上树立了6米×9米的雕塑6件。Way of Existence is 80 meters in length, comprised of 43 glass panels. The numbers etched on the 2nd to 43rd panel are the digital equivalent of the words on the first panel. Visitors can walk on it. Engraved on the glass is the artist's ode to life and the future. On the surrounding open ground stand six sculptures, six metres wide and nine metres tall.

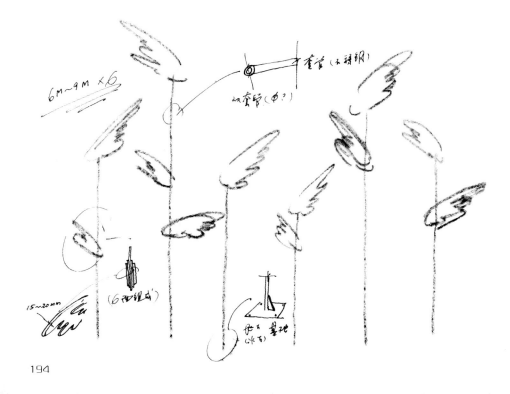

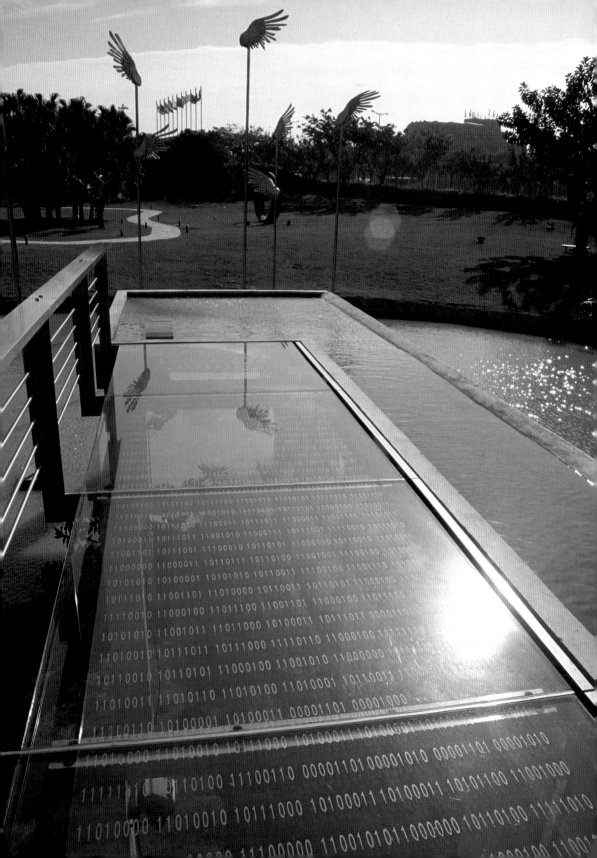

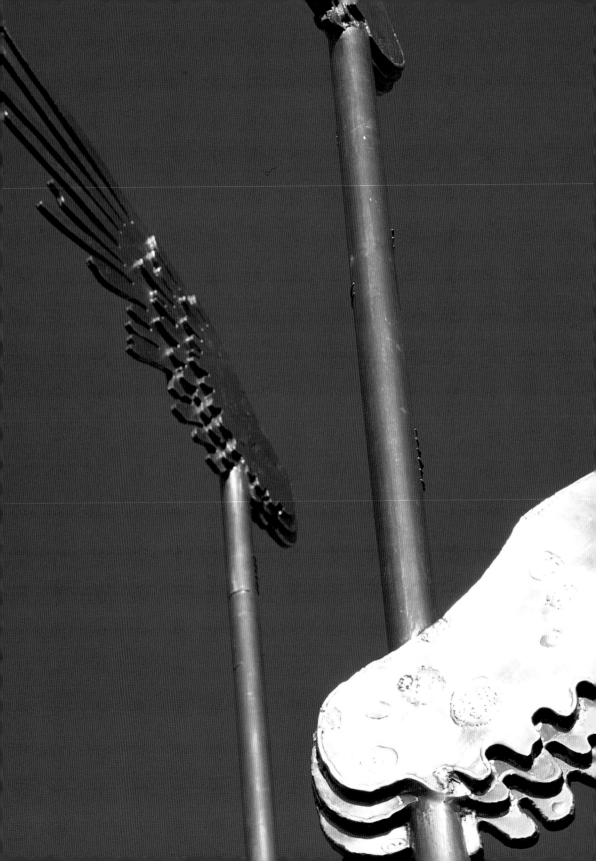

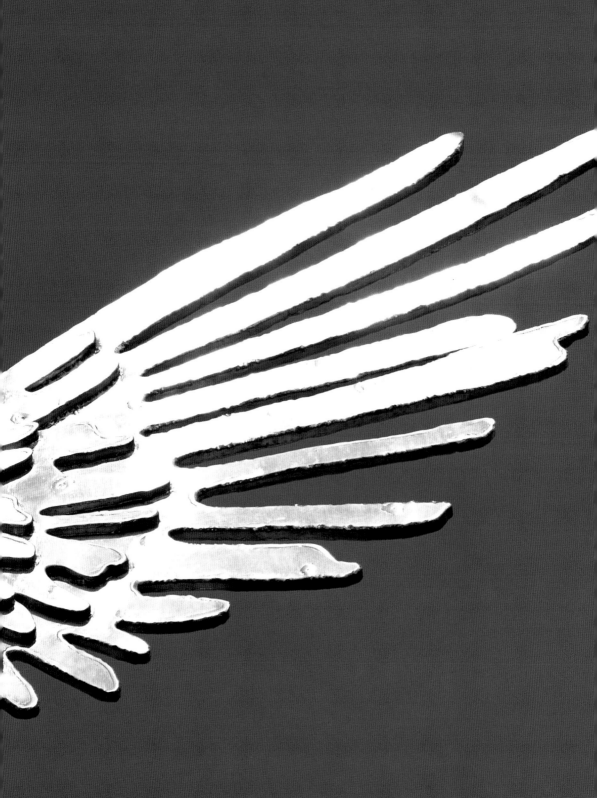

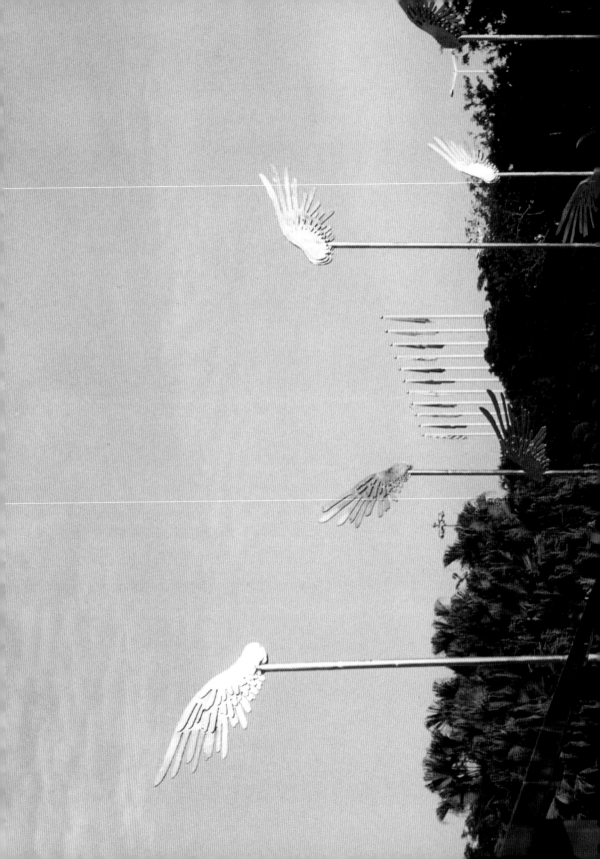

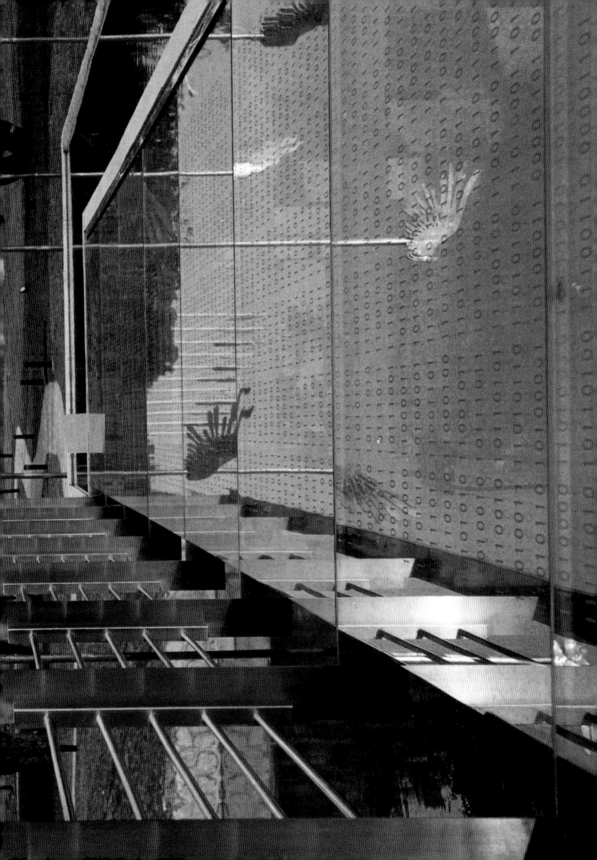

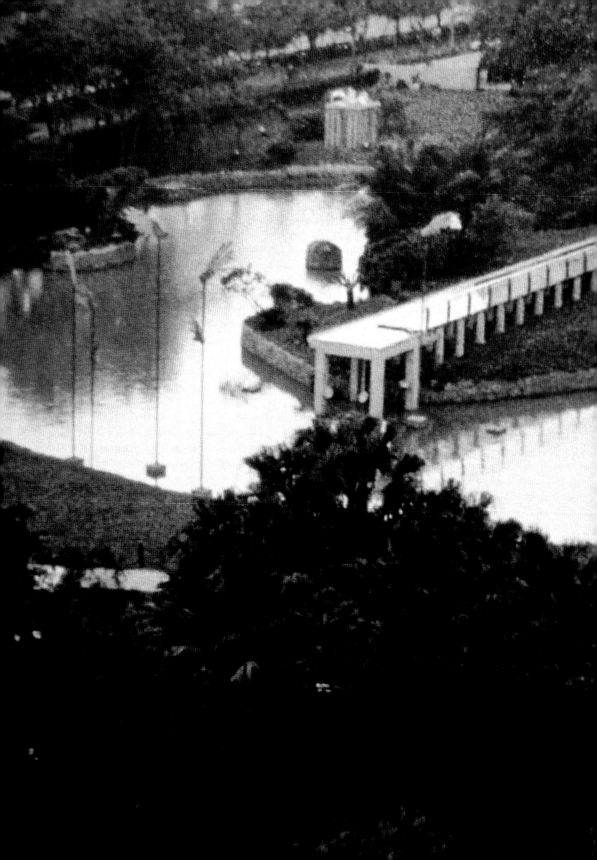

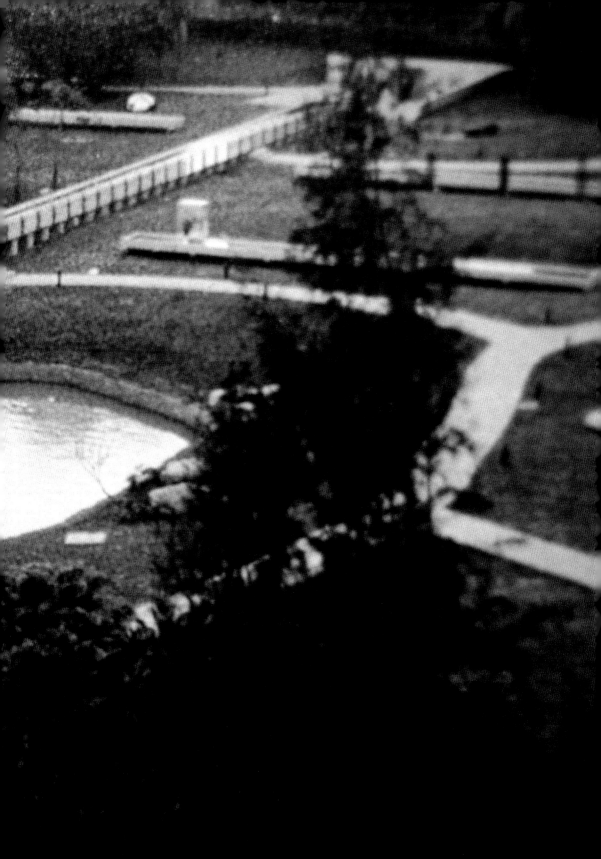

生存之道既是一条具象的"道路"也是一种东方式的形而上的"道"。这件环境艺术作品更多带有观念艺术的特征。The way of Existence proceeds towards a luminous idealism at the other shore, balanced between illusion and reality, artifice and nature, technology and artistry. Such is the way of existence for humanity. This is the concept clearly evidenced in this work.

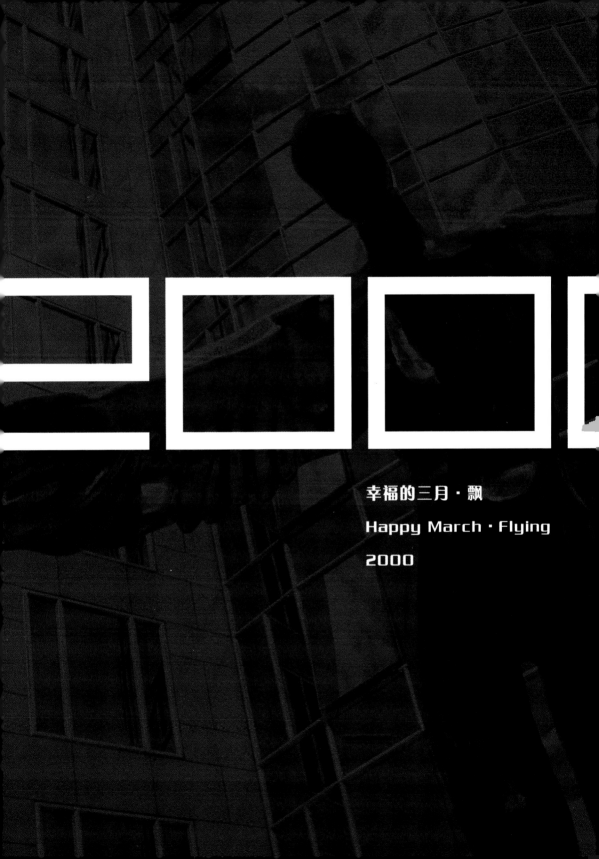

2000

幸福的三月·飘

Happy March·Flying

2000

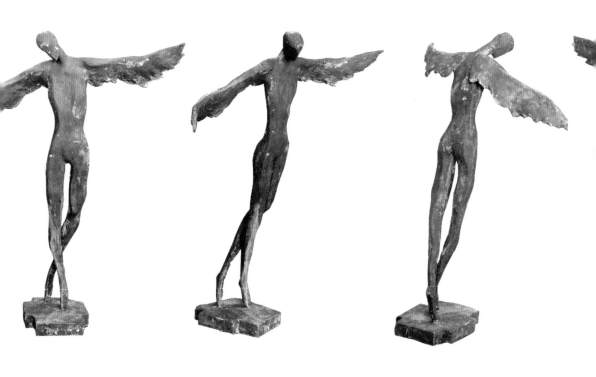

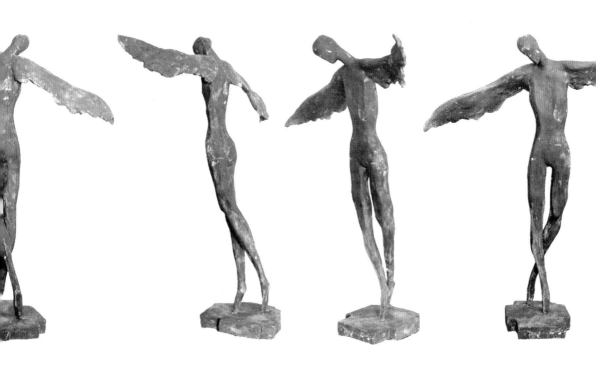

矗立在北京长安街王府井大街十字路口东北角，东方广场西侧，尺寸：5米X4.8米，材质：钢、不锈钢、烤漆。This sculpture stands on the northeastern corner of the main Wangfujing crossroads in Beijing, on the eastern side of Oriental Plaza. It is 500 cm by 480 cm and made of lacquered stainless steel.

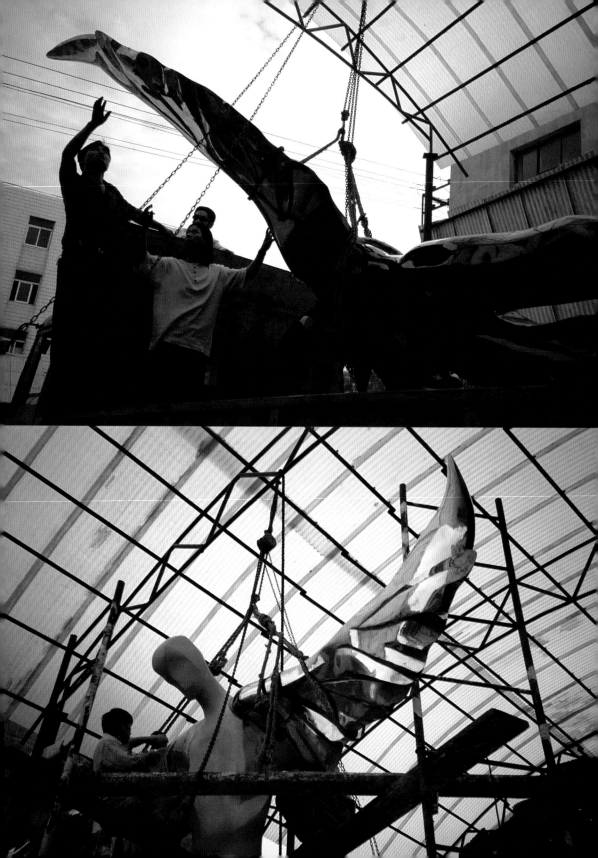

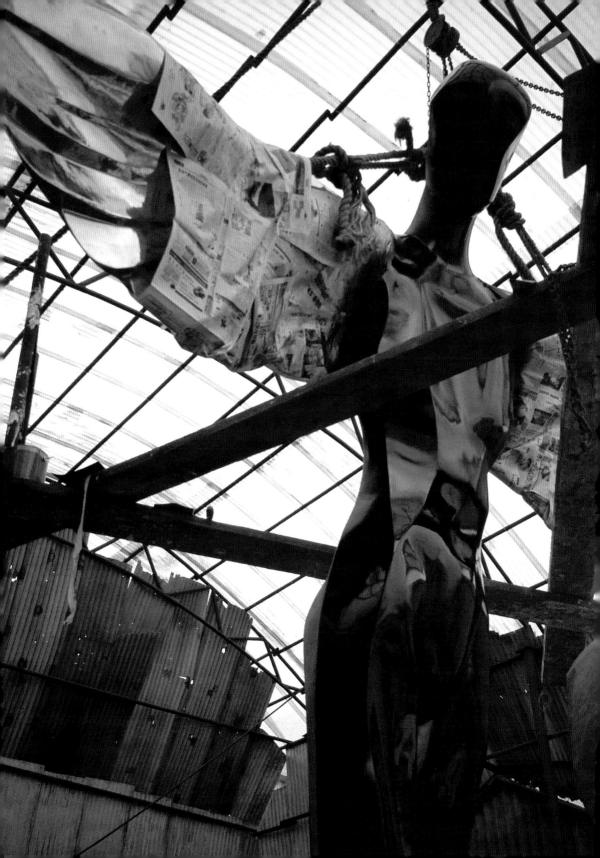

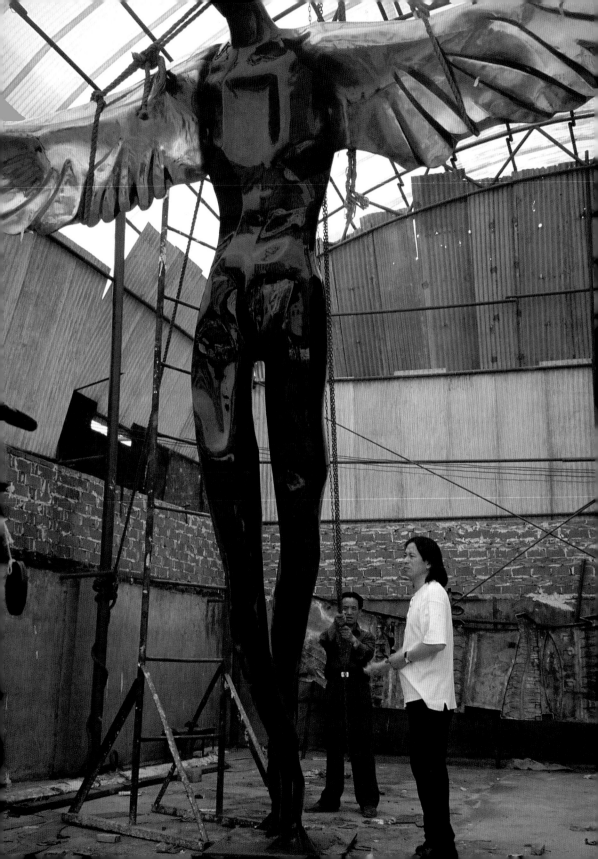

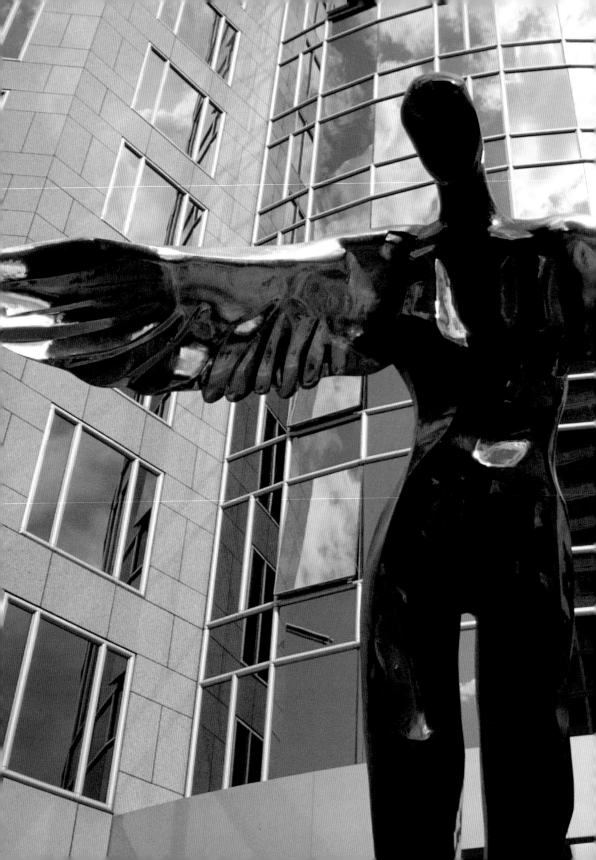

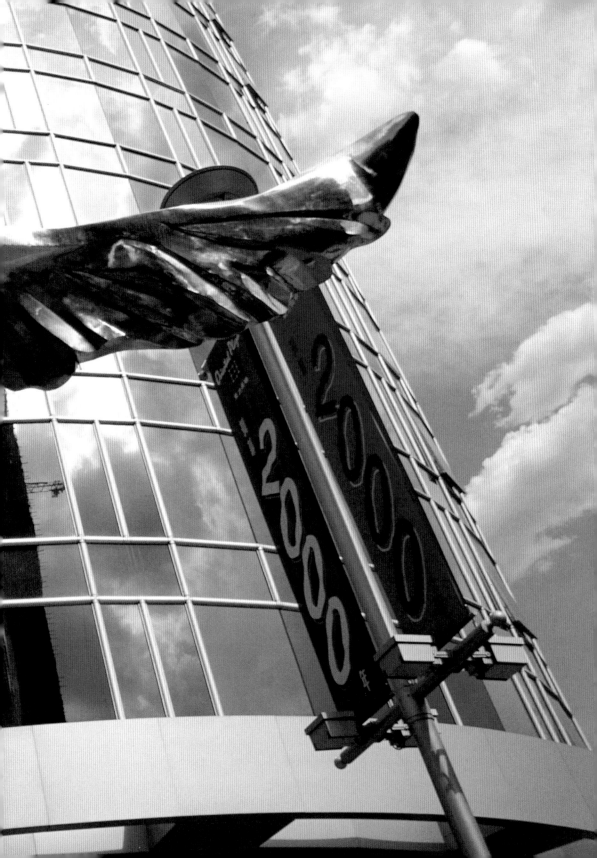

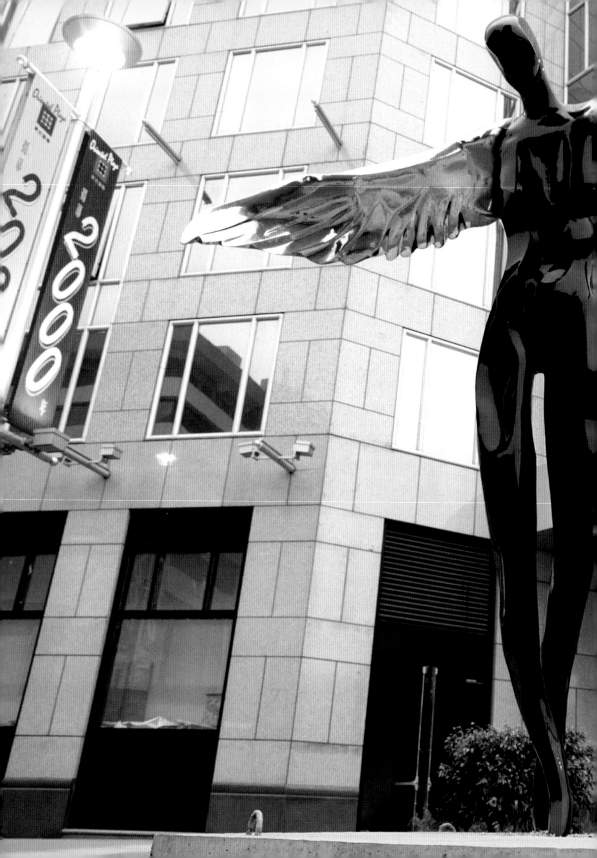

《飘》的出现，经过《新周刊》等主流媒体的推广，使"飘"成为新一代生活观念和状态的代名词。而米丘本人也被《新周刊》称为"飘一代"的艺术总监。The 'Happy March·Flying' piece was widely reported by the media and has come to embody the life-style of the new generation.

愿望 2000

Wish 2000

2000

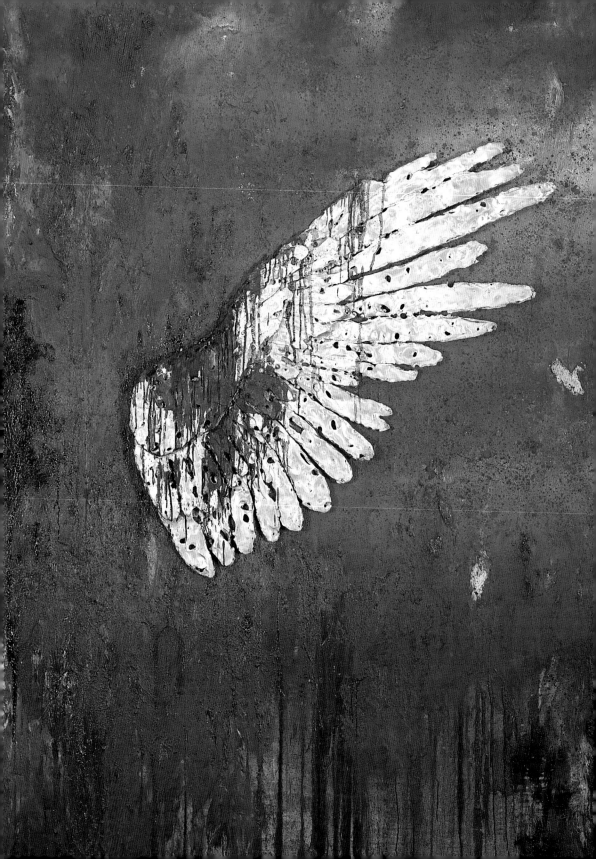

通过 INTERNET 上的 Wish-2000.com 收集来自世界各地对于新千年的愿望，从中选出 200 条愿望，铭刻在伸入大海中的长达 99 米宽 5 米的玻璃愿望桥。然后在大梅沙海滩上建立由七件雕塑组成的"愿望"的雕塑群，同时在海边建造高 81 米的由玻璃和不锈钢架构成的愿望塔，塔上的多媒体装置可供游览者发布愿望。Mi Qiu collected wishes from people for the year 2000 via WISH-2000.com. He selected 200 entries and printed them on the glass 'Wish Bridge', which extends 99 metres into the sea (5 metres wide). In addition he produced a group of seven sculptures to be placed on the beach, and constructed an 81-metre high 'Wish Tower' made of glass hung on a steel frame. Multi-media technology was used to allow visitors to submit their wishes.

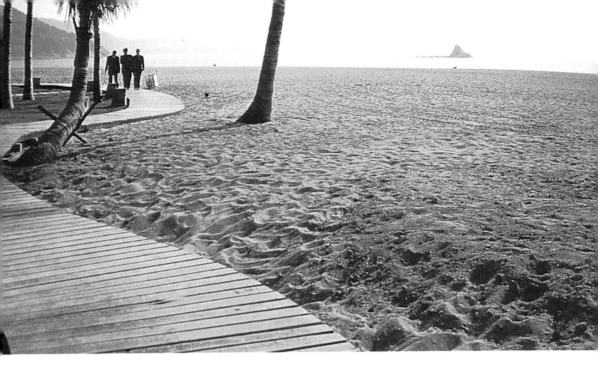

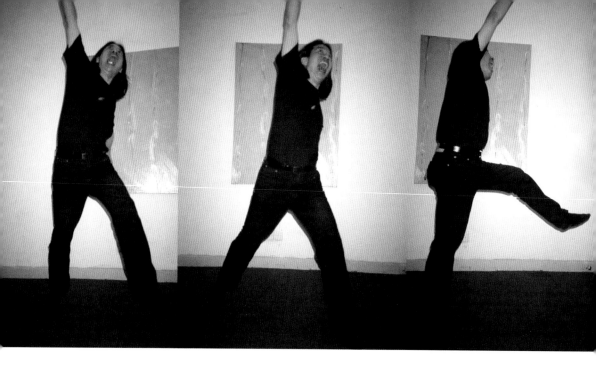

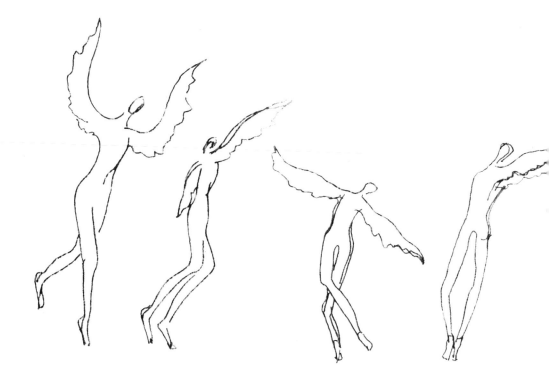

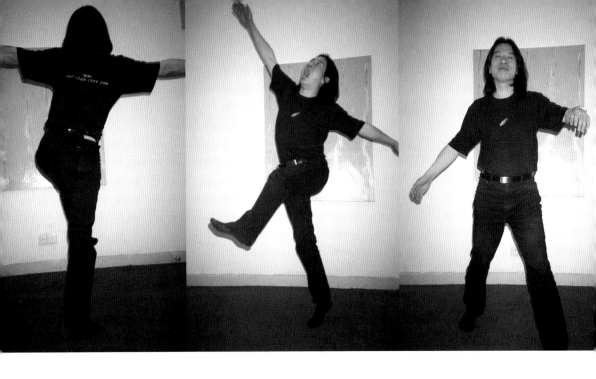

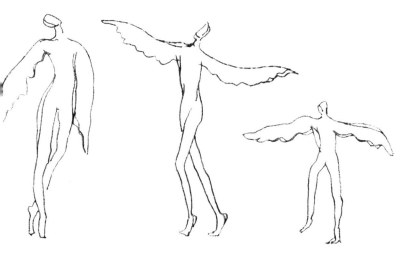

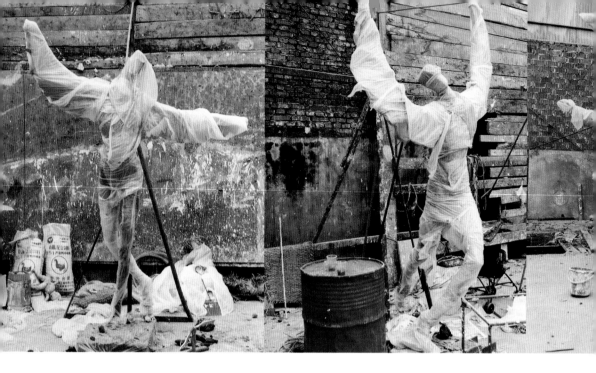

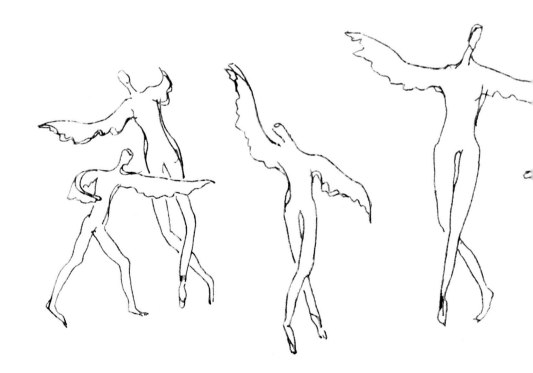

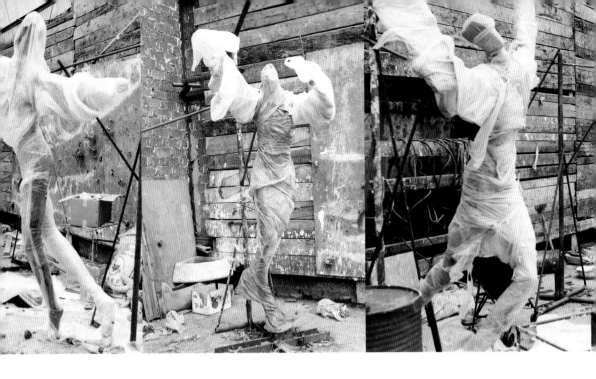

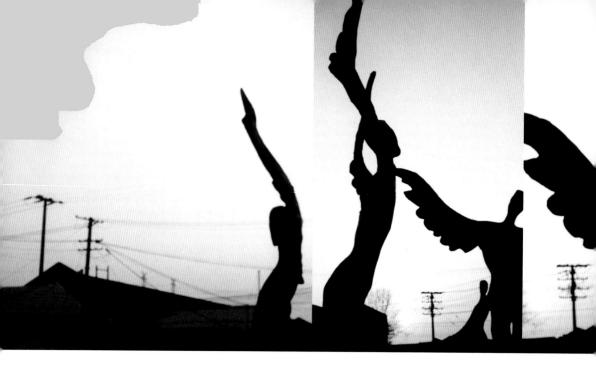

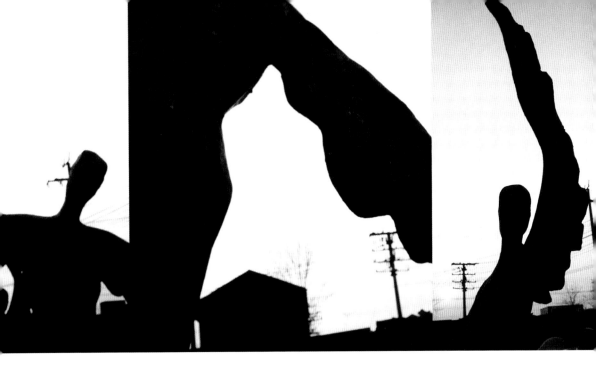

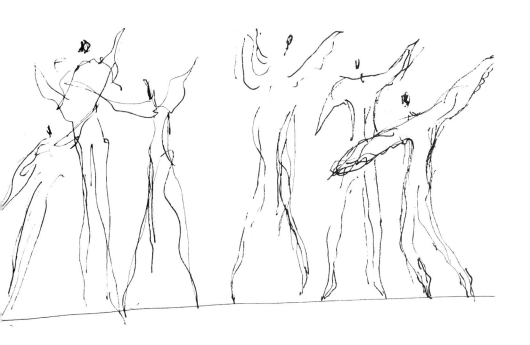

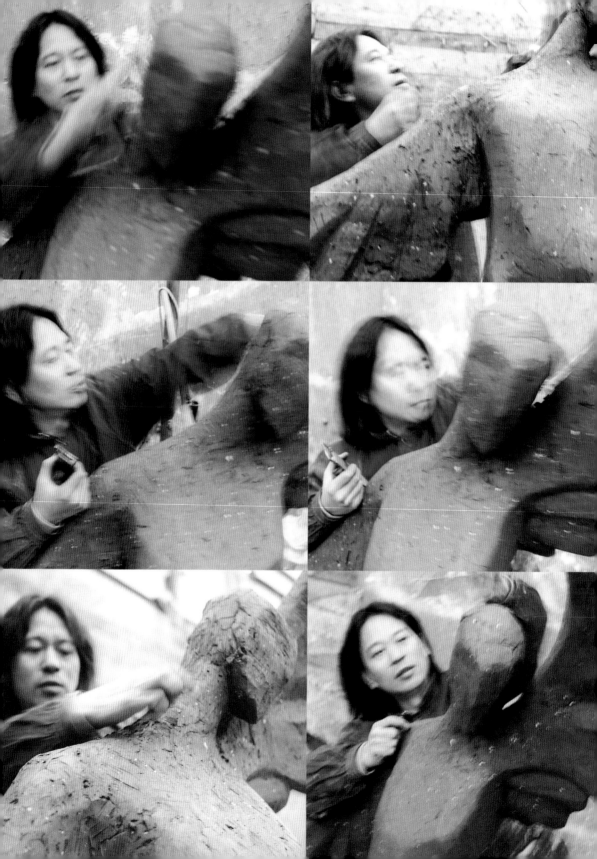

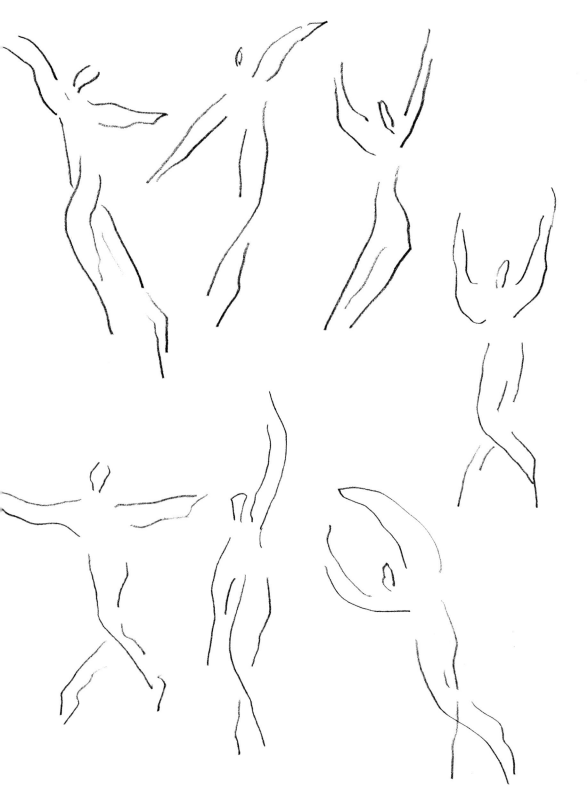

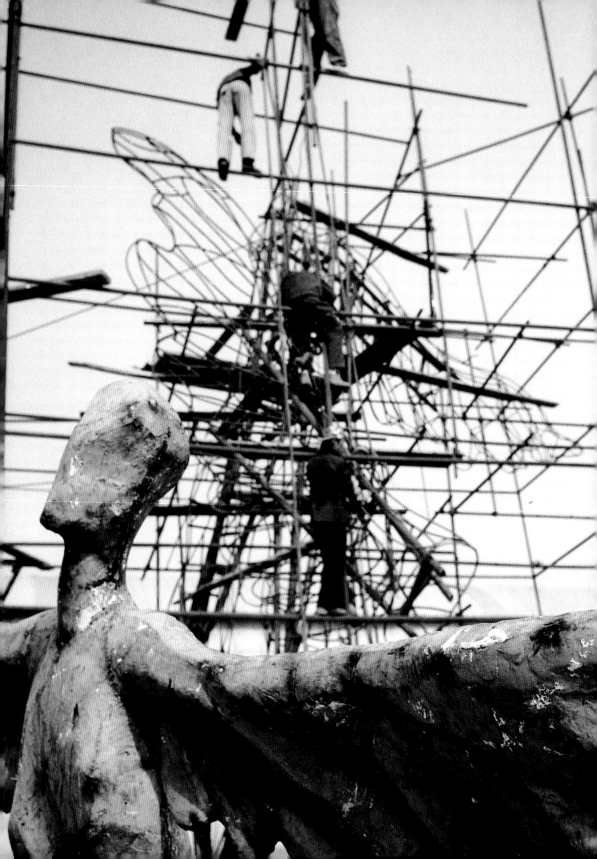

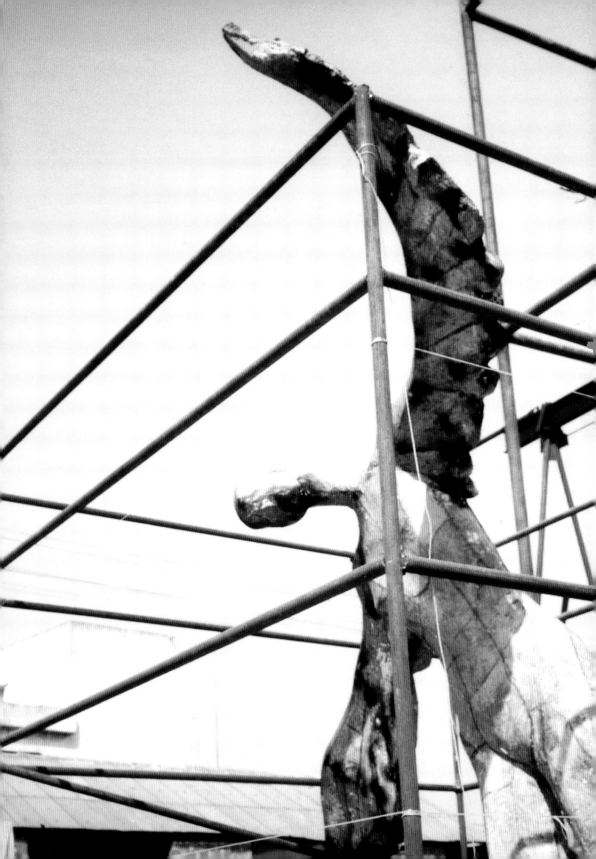

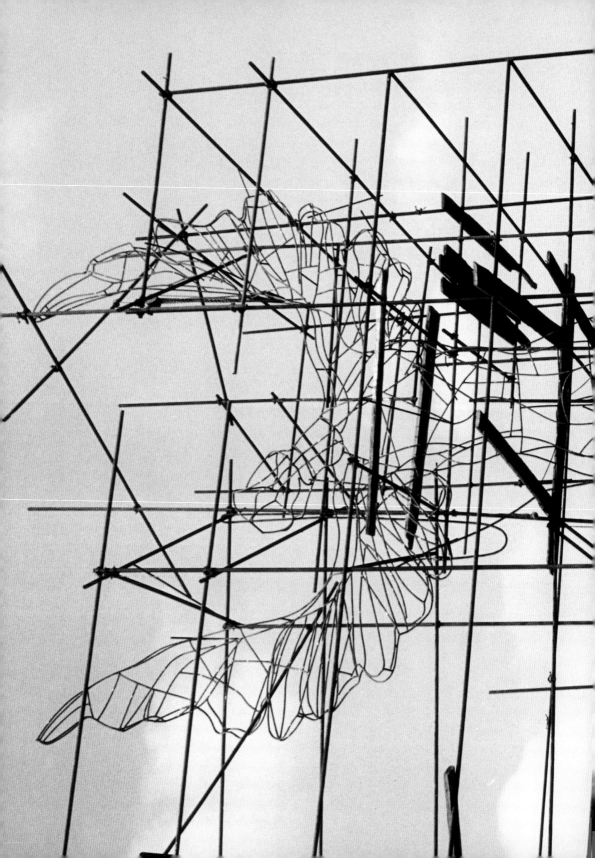

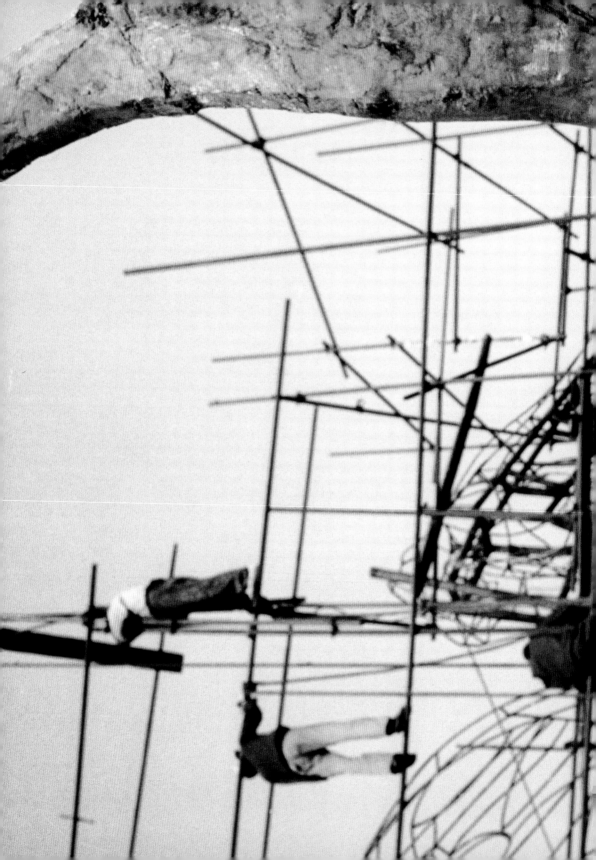

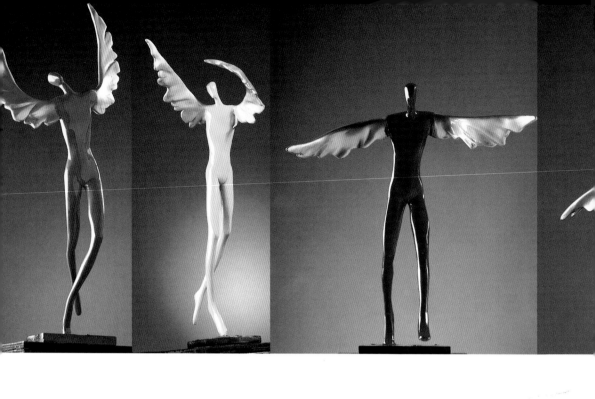

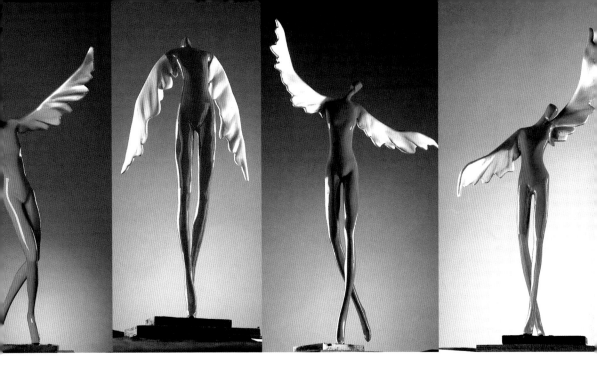

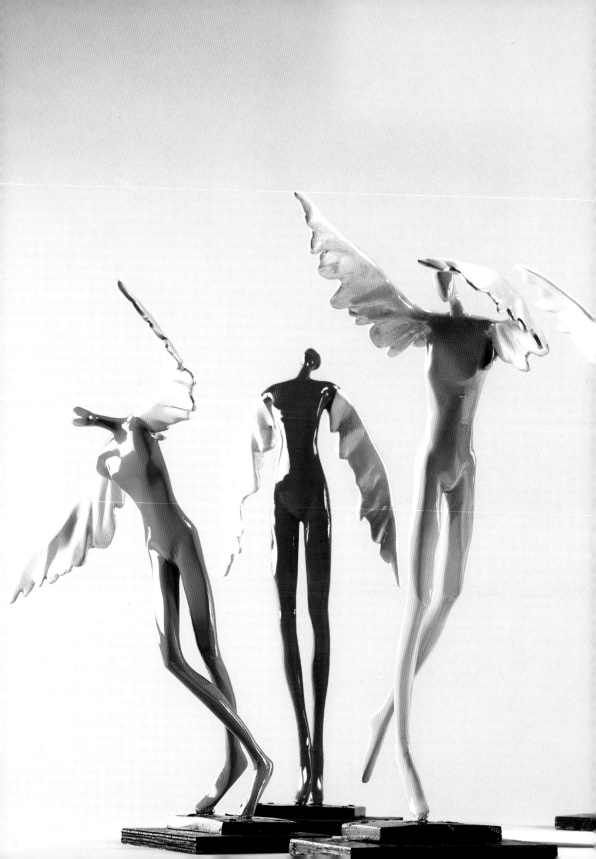

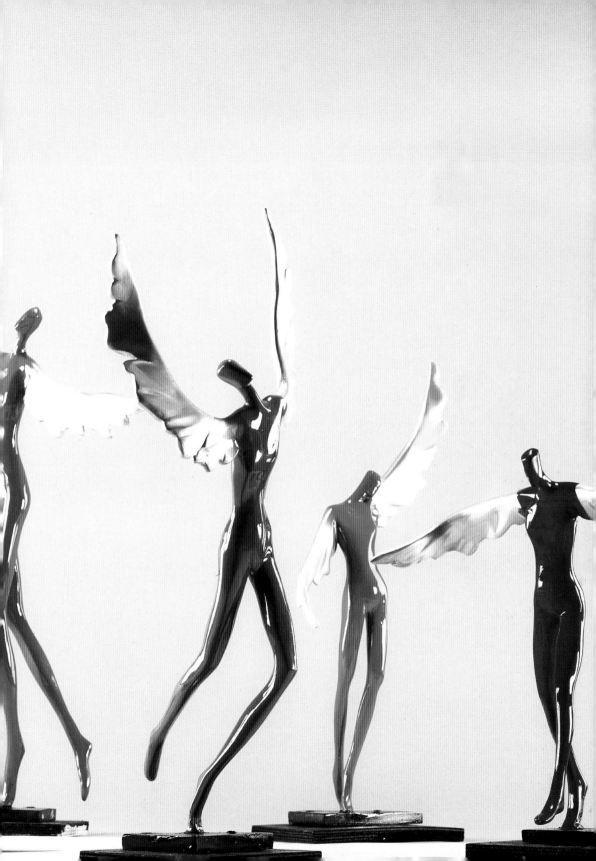

这件作品是中国规模最大的一次综合艺术作品，是一次难度极大的跨平台操作，展示了米丘综合的个人素质，同时也为中国未来的当代艺术提供了一种新的可能性。This project is the largest integrated artwork in China and involved the co-operation of many different elements. It demonstrates Mi Qiu's personal all-round accomplishments and also provides Chinese contemporary art with new possibilities for the future.

评论摘要　　　　　　　CRITICISM

米丘是中国第一代完全了解西方现代主义的艺术家。艺术作品以个人的个性和文化特性为中心，旨在表现民族传统文化如何与外界的冲击、压力相结合。这种艺术运动的兴起对今日的中国尤为重要。因为中国社会正经历了快速的变化，保护文化遗产和传统至关重要。米丘对西方现代主义有充分了解，同时对中国传统艺术有很深的洞察力。在当前的艺术运动中起了重要的作用。**《Y 计划》1996 年 培尔 霍夫德拿克** Mi Qiu belongs to the first generation of Chinese artists who have been fully and widely exposed to Western modernism. His works focus on the spirit of the individual and the particularities of culture. They express the impact and pressure that western influence has on traditional Chinese culture. The rise of this art is especially important in China today. The protection of tradition and cultural heritage is of the utmost importance because Chinese society has experienced rapid development. Mi Qiu has a deep understanding of both western modernist and Chinese traditional art, which plays an important role in the contemporary art movement. **"Y Project", Per Hovdenakk, 1996**

米丘离乡是为了接受三个考验：首先看自己可否从零开始发展，其次是检视自己沉积了二十多年中国传统，是否仍可接受新事物，再者是找出西方发展与社会的关系。他认为，现代艺术并非不沾人间烟火的玩意和抽象的概念，而是跟现实社会有密切联系。**文化大使徜徉东西方艺海《亚洲周刊》1997 年 1 月 27 日 融合** Mi Qiu left China in order to test himself in three ways. Firstly, he wanted to see if he could start afresh. Secondly, he wanted to see if, after living 20 years of Chinese traditional life, he could accept ideas from the West. Thirdly, he wanted to see how Western development affects society. Mi Qiu believes that modern art is not an abstract concept, but is linked with modern social life. **A Cultural Ambassador of the East and West, "Asia Weekly", 1997**

他不接受一切粘滞的归属，把自己的活动范围开拓得很广，现代油画、抽象水墨、表演艺术、行为艺术、文化策划、艺术管理，——介入。他软化、甚至取消了其间的种种界限，因此也就软化、甚至取消了对抗。他也不认为艺术的思考性和流行性不可互容，必须对抗，相反，从他的作品中可以看出，他努力在两端之间寻找与广大观众对话的空间。他的作品并不通俗，常常剔除了易度符号通达原始情结和整体意绪，但正因为这样，他以真诚的空间为观众提供了参与的可能。他以自己对社会的广泛参与，换来观众对艺术的广泛参与，而一切参与都是最深刻的对话。**欢迎米丘《文汇报》1998年10月21日 余秋雨** Mi Qiu won't accept any fixed categorizing. His talents are much broader – modern oil painting, abstract painting, watercolor painting, performance art, action art, organizing cultural activities, and art administration. Mi Qiu has blurred, to the point of dissolving, the boundaries between these areas. Instead of conflict, they can now blend. He does not believe that what is popular cannot be intelligent, or that one precludes the other. On the contrary, he has tried his best to create a space in his work where he communicates this to his audience. His works are anything but ordinary. Yet precisely because of this, he has made it possible to have a space in which people can have an open discussion. His broad participation in society has brought a wider participation of people to art. **"Wenhui Daily", 1998**

米丘在上海几乎成了神话般的人物。作为建筑师他参与过24座历史名城的重建规划等国家建设项目，作为艺术家旅欧8年，除了艺术创造，他创立了庞大的"欧中文化交流计划"。回国后，他完成了一系列城市环境设计，并且形成了一个关于艺术和技术的新概念—ArTech，由此联络了一个艺术加技术的群体深入地推进着上海的环境建设。**在技术世界中，艺术家何为?《生活周刊》1999年第10期** Mi Qiu has become almost a mythical figure in Shanghai. As an architect, he has participated in the renovation of 24 historical cities across the world. As an artist, he traveled around Europe for eight years. In addition to his art, he also organized the large "Sino-European Cultural Exchange Project." After returning to China, Mi Qiu completed a series of designs for urban environmental art. He came up with a new concept for integrating art and technology – ArTech. This group was to become heavily involved in environmental construction in Shanghai. **What are Those Artists Doing in a Technological World? "Life Weekly", October, 1999**

米丘的作用在观念的有效性上一直有着明确的表现方向，这里"观念"不再是一种无法言说的"感觉"和关于一个事件的叙述或呈现，"观念"在它设定的反对的对象中产生，并在这个设定中提供一种判断和提问，这在其他艺术工作者不明白的当下，米丘在"观念"维度上变得越来越有自己的观察点，这个点将有关于制度、行为、心理等一系列现成概念和话题形成的时尚变为审视的对象。我们已经在他那观念作品的系统中看到他对艺术概念的一次次突破的轨迹，这组成了他的观念艺术的场面，而在米丘的绘画领域这种在不同的题材中对不同的综合材料的大量使用，又使米丘的绘画成为不间断瞬间诗意留下的痕迹。**针对社会的艺术诗意的独白与米丘绘画《媒体的干涉》展1999年5月　王南溟** Mi Qiu's usefulness is his effectiveness in expressing all opinions – his direction is clear. This "opinion" is more of a "feeling" that cannot be expressed, it is an intuitive knowledge. We have already seen how he constantly surpasses his achievements with his Opinion Art. In his many different materials and different themes, Mi Qiu's works leaves traces of each romantic moment. **"Media Interruption" Exhibition, May 1999**

思想像一颗看不见的种子那样，落在艺术家的心灵上，在建筑一个空间的同时，更应注重建筑它的灵魂。不断发现某种美的东西，并把美尽可能广泛地带到生活中去，是一种神圣心灵的标志。米丘从自己的心灵出发，再度强化了一个较温和又较有包容的"宽容精神"的概念。**米丘的使命《海上文坛》1996年11月　钟雪燕** Thought is like an invisible seed in the heart of an artist. In building a space you must also create its soul. Continually finding beautiful things and then bringing them to life is an example of pure soul. From his heart, Mi Qiu exemplifies a spirit of tender acceptance. **"Hai Shang Wen Tan"(HSCW), November 1996**

为何米丘能创造奇迹？并非偶然，也非仅靠运气。他身上同时集中了三种素质，我想就是他能成功的原因。第一，他是一个出色的艺术家；第二，他了解中国；第三，他了解西方。同时具备这三种素质，又能占有一个对艺术界深具影响力的职位，这种组合在当今大陆及大陆在海外的所有艺术家中，就我所知几乎是绝无仅有。**他会成为中国现代艺术的教父吗？《香港文艺》1996年第2期 王力雄** How can Mi Qiu achieve such wonderful creations? It is not through coincidence, and not through good fortune. The three strengths that make him such a success are: first, he is a distinguished artist; second, he understands China very well, and; third, he understands the west very well too. Because of these strengths, Mi Qiu has a very influential position in the art world. This combination is what makes Mi Qiu unique among contemporary native and overseas Chinese artists. **"Hong Kong Art and Culture", 1996**

艺术家给人的印象大都是自我执着，但致力于融合中西文化的大陆旅欧艺术家米丘却强调宽容，对于各种文化艺术皆取长舍短。他不但吸收文明，而且要创造文明；不但创作行为艺术，而且要自己的人生成为一场行为艺术。**米丘：中欧文化交流使者《ELLE》第114期 马建 1997年** The impression that most artists give is of a limited style. But Mi Qiu is known for a variety of styles, taking the best parts from all arts and cultures. Not only does he accept culture, he creates culture. Not only does he create action art, but he wants his life to be a piece of action art. **"Elle", 1997, 114th Edition**

米丘年表 CHRONOLOGY

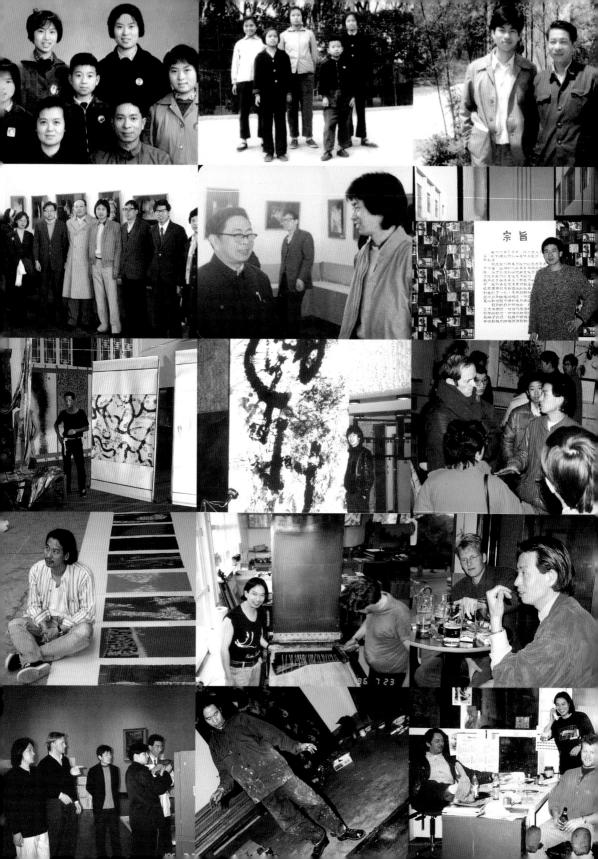

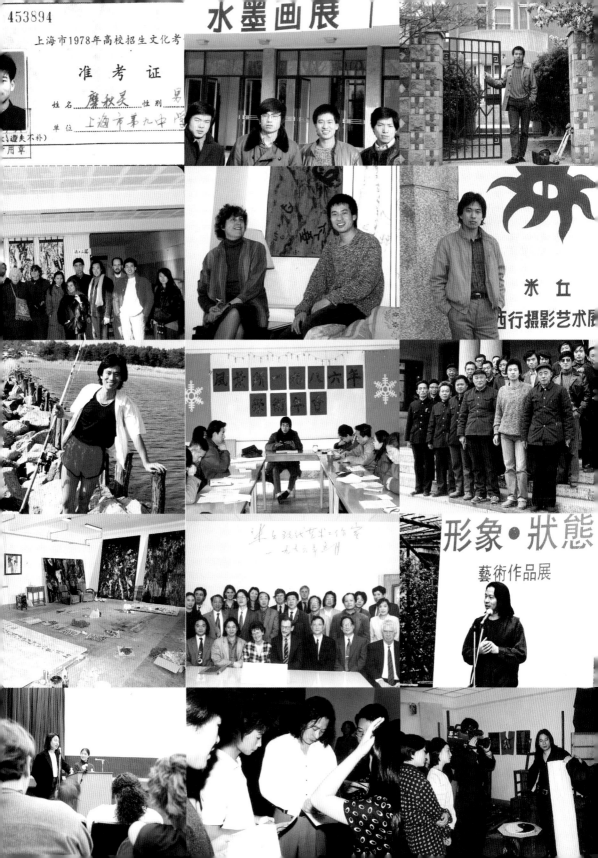

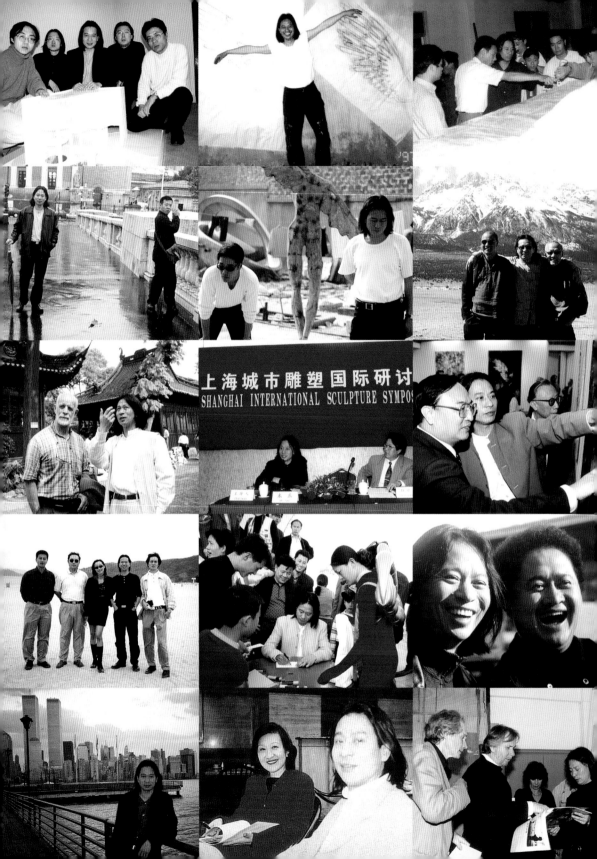

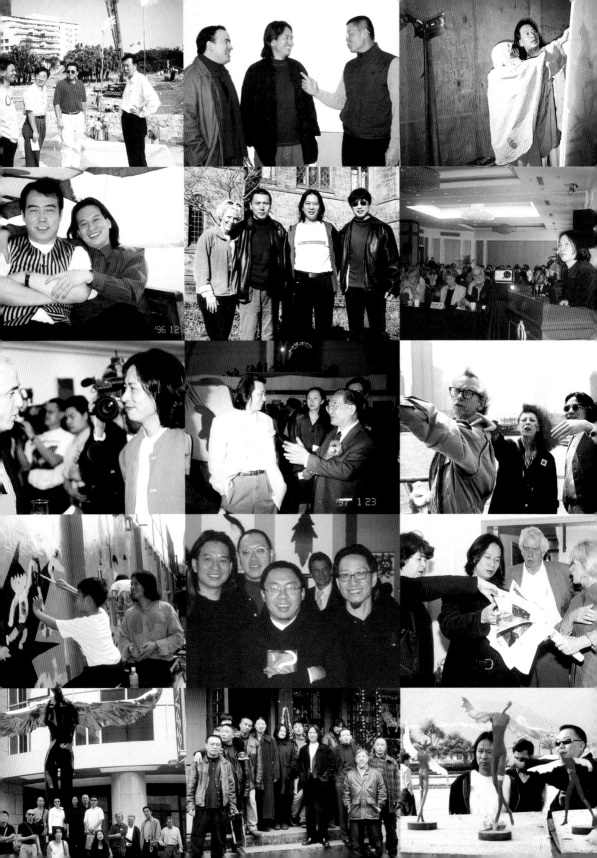

米丘，生于1960年，上海人，毕业于同济大学建筑系，职业艺术家，1982年至1987年在中国城市规划设计研究院，参与中国24个历史文化名城和44个国家级风景区规划和重建；1987年移居欧洲，在全球举办了近30个艺术展览；1993年创建《欧中文化交流计划》简称ECCEP；1993年为海涅·昂斯塔得艺术中心研究员，1995年为艺术总监；1996年创立《米丘现代艺术工作室》；1998年获MOVADO文化艺术杰出贡献奖，同年提出ArTech概念；1999年在上海的中国人寿保险大厦、深圳华侨城等地创作以"幸福·生存"为主题艺术作品；作品"生命之骰"于1999年获世界黄金协会大奖；2000年在深圳大梅沙"WISH2000艺术计划"，它是中国规模最大的、构成最综合的环境艺术作品。从建筑转向绘画，米丘于1985年举办了中国最早的现代艺术展。艺术与环境的结合形成了米丘独特的空间概念，他在上海成立的工作室进行了30多项艺术交流项目，而近期将绘画、雕塑、建筑、多媒体融于一体的"愿望2000"艺术计划则被称为创造深圳新文化的开始。"愿望2000"艺术计划也将于2000年在美国纽约实施。他的具有象征意义的"羽翼"成为了他个人的艺术形象。2000年被评为中国十大新锐人物之一。2000年矗立在北京东方广场上的又一新作〈〈幸福的三月〉〉（又名〈〈飘〉〉），成为北京长安街标志性作品。**Mi Qiu** was born in Shanghai in 1960. He graduated from Tongji University, in Shanghai, with a degree in architecture. He is a professional artist. From 1982 through 1987, he worked at China City Design Research Center, where he participated in reconstruction projects in 24 historical cities as well as 44 officially preserved landscape sites. In 1987, he emigrated to Europe. Since that time, he has shown upwards of 30 exhibitions of his work at locations throughout the world. In 1993, Mr. Mi established the Europe-China Culture Exchange Project. In 1995, he served as a researcher at Henie-Onstad Art

Center. In 1996, he established the Mi Qiu Modern Art Workshop in Shanghai, where more than 30 art exchange projects were accomplished. In 1998, he received the Movado Outstanding Contribution to Art Award. That same year, he created the "ArTech" concept. In 1999, he used "Happiness/survival"(Xingfu Shengcun) as the subject of sculptural work created for several different locations, including the China People's Insurance Building in Shanghai and the Overseas-Chinese City in Shenzhen. In 1999, he won the Grand Prize of the Golden Society for his work "The Dice of Destiny" (shengming Zhishai). A recent project of his in the Dameisha area of Shenzhen, the "Wish 2000 Art Project", is the largest-scale environmental artwork in China and involves tremendous structural diversity. Mi Qiu has not only distinguished himself in architecture, he has also been noted for his contributions to modern painting. Indeed, in 1985, he presented one of the earliest modern art exhibitions in China. As for his work of integrating art into the environment, this follows Mi Qiu's distinctive "Space Concept" (Kongjian Gainian), a concept finding perhaps its fullest realization to date in the "Wish 2000 Art Project" in Shenzhen. In this installation, one may say that painting, architecture and sculpture as well as multimedia are merged into a single idea. This work will be implemented again in New York in 2001. Mi Qiu's sculpture "Wings" has become something of a symbol in the popular imagination, and it was due to this work that he was recognized as "one of China's Ten Most Avant-Garde Artists." In 2000, his new sculpture "The March of Happiness"(also known as "Gone with the wind") was installed in Beijing's Oriental Square(Dongfang Guangchang), and has become inseparable from Beijing's famous Changan Street.

展览 1986.1 北京古观象台"抽象水墨画展" 1986.11-87.4 北京清华大学"抽象水墨画展" 1987.1 北京加拿大驻华使馆"抽象水墨画展" 1987.8 北京好圆饭店"抽象水墨画展" 1987.11-88.1 奥斯陆维格兰美术馆"米丘艺术"展 1988.1-2 奥斯陆诺斯克、阿基太特美术馆"抽象水墨、油画"展 1988.11-12 纽约长岛艺术中心"抽象水墨" 1989.9-10 斯塔温哥艺术中心"米丘艺术"展 斯塔温哥 1989.10-12 奥斯陆 奥斯陆大学"油画展" 1991.4-6 斯特纳兰画廊"水墨、油画"展 奥斯陆 1991.7-8 丹麦斯特纳兰画廊"米丘油画"展 1991.7-8 蒙耐费斯肯文化中心"宇宙风景"展 1991.11 凯雨奥森画廊"水墨、油画"展 1993.4-6 波特莱影像中心"交往（油画、行为艺术）" 1993.5 海涅·昂斯塔艺术中心"以艾滋为题—传真行动及行为艺术"及奥斯陆中心广场 1993.6-9 芬兰·瑞典"芬兰1993 SHAMAN之夏" 1993.9 卑尔根"5000只气球（行为艺术）" 1993.11-12 德国"国际行为艺术家大会"展 1995.10 克里斯蒂画廊米丘版画展 1995.11 海涅·昂斯塔艺术中心藏画展 1996.11 香港大会堂"Y Project"展 1997. 香港艺术中心"意象之外"展 1998.12 何香凝美术馆藏画展 1999.3 香港"媒体的干预"展 1999.3 美国新泽西画廊"米丘版画"展 1999.10 第二届当代雕塑年度展 2000.3 美国MUS艺术馆"超越界眼"展 EXHIBITIONS 1986, anuary "Abstract Chinese Ink & Wash Paintings", The Old Observatory, Beijing 1986, Nov-1987, Jan "Abstract Chinese Ink & Wash Paintings", Beijing University and Qing Hua University 1987, January "Abstract Chinese Ink & Wash Paintings",Canadian Embassy, Beijing Haoyuan Hotel 1987, Nov-1988, Jan "Abstract Chinese Ink & Wash Painting", Oslo Vigeland Art Museum 1988, Jan-Feb"Abstract Chinese Ink & Wash Painting", "Oil Paintings", Oslo Norsk/Architect and

Art Museum 1988, Nov-Dec "Abstract Chinese Ink & Wash Paintings", "Oil Paintings", Sung Harbour Cultural Centre on Staten Island, New York 1989, Sep-Oct"Abstract Chinese Ink & Wash Paintings", "Oil Paintings", Gallery Slvberget, Stavanger 1989, Oct-Dec"Oil Paintings", Stena Line Gallery, Oslo University 1991, April-June"Abstract Chinese Ink & Wash Paintings", "Oil Paintings", Stena Line Gallery, Oslo University 1991,July-August "Abstract Chinese Ink & Wash Paintings", Stena Line Gallery, Denmark 1991,July-August "Universal Scenes" in oil and "Abstract Chinese Ink & Wash Paintings", Monefisken Art Workshop 1991, November "Abstract Chinese Ink & Wash Paintings", "Oil Paintings", Kai Olsen Gallery 1993, April-Jun "Communication (Oil Paintings, Action Arts)", Voice Video Centre 1993, May "Aids-Fax Action & Action Art", Henie Onstad Art Centre and Oslo Centre Plaza 1993, Jun-Sep"Summer 1993 Shaman in Finland", Finland and Sweden 1993, September "5000 Balloons"(Action Art), Bergen 1993, Nov-Dec "International Action Artists Congress", Germany 1995, October "Wood Cuts", Christie Gallery 1995, November "Art Collection", Henie-Onstad Art Centre 1996, November "Y Project",Hong Kong City Hall 1997, April "Chinese Abstraction & Beyond", Hong Kong Arts Centre 1998, December "He Xiangning Art Gallery Exhibition" 1999, March"Medium Interfere Exhibition" Hong Kong 1999, March "Montclair State University, New Jersey Exhibition" 1999, October "The Second Yearlong Contemporary Sculpture Exhibition" 2000,March "Transcending Boundaries" MUS Art Gallery America

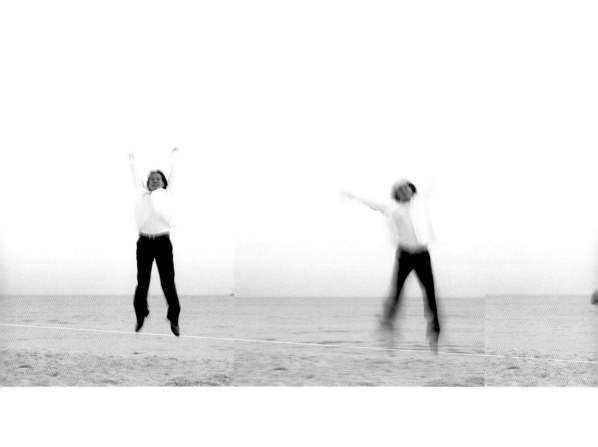

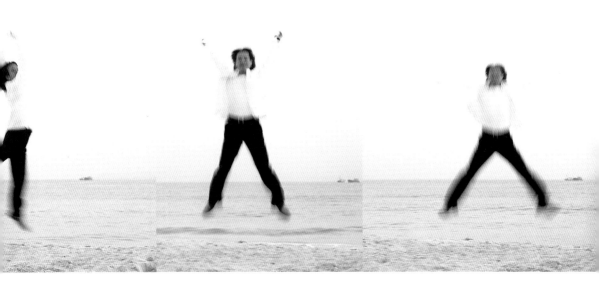

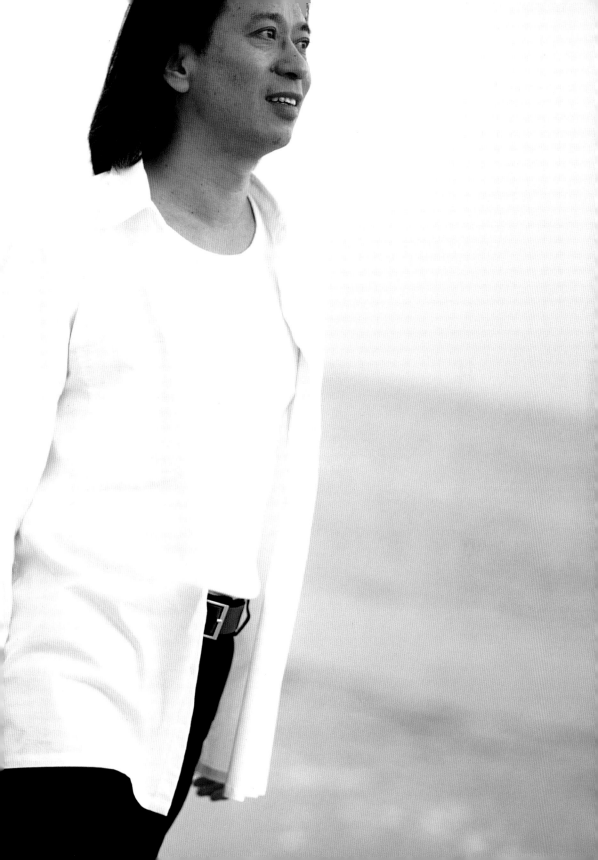

后记 EPILOGUE

2000年八月，中国建筑工业出版社编辑王雁宾先生给我来电说，要出版一本关于我的作品的书，我很直率地告诉他，已经有好几家出版社向我约稿出书，我也正在与他们洽谈之中。建工出版社为什么要给我出书？他的回答是：我们原来在建设部同一个大院工作生活过五年，而且这本书的选排和出版时间将全部由你来决定。我当时感觉非常亲切：虽然我已经离开这个系统近十五年了，他们依然记得我。事后我知道，其实还有更多过去的同仁一直在关心着我的工作。也许，正是从事这样一个古老而现代行业的人，才有这样一种特殊的心态和感情。没过几天，我就和出版社的编辑相约在上海见面，并决定出版此书。我打电话给我的朋友〈〈三联生活周刊〉〉主笔舒可文，请她给这本书写序，而她则建议由她先生赵汀阳教授来写，赵汀阳先生也是我的好朋友，每次我们相见，或在旅行中，或在互通电话中，我们始终有着很愉快的聊天时光。很快我让我的朋友柴宁参与了此书的删选和编辑工作，设计师姜庆共先生在看到书稿内容及照片之后，充满激情地前后用了几个月的时间，最终让我欣慰拥有了这样一个完美的设计作品。1987年我离开中国，直到1996年才回国，国外的近十年的生活这样过去了，回到中国的几年也就这样一晃而过。尽管我是一个随遇而安的人，尽管此书只是记载了我的一部分艺术活动，但它却是我的部分生活历程和记忆。

回国不久，我的老同学，建筑师乐星约我见面希望与我合作，一下子使我感觉回到了十几年以前亲切而又单纯的学生生活。还有我的学弟徐良、黄向明和陆奋，他们都是同济大学的佼佼者。正是由于这样的合作才有了中国人寿保险公司的环境艺术的完成。之后，又完成了何香凝美术馆第二届当代雕塑艺术年度展的环境设计，这里我得感谢华侨城的总裁任克雷先生及副总裁陈剑先生和何香凝美术馆副馆长乐正维女士。为此设计师韩家英做了一

个完美的整体平面及出版物的设计，给人留下深刻的印象。在我这几年的工作中，摄影师陈海汶、肖全、陆元敏始终如一地对我的工作做了全面的纪录，留下了许多精美的摄影作品。这种执着的态度，让人感动。生活和工作中能得到那么多人的关爱真是太幸运了。当《愿望2000艺术计划》最终令人难以置信地在深圳大梅沙趋于完成的时刻，我要感谢深圳市盐田区政府和深圳市规划国土局盐田分局的同仁们，如果没有戴北方，吕锐锋先生做出的前瞻性的决策，没有许重光先生全面、无私地支持，没有乔恒利，徐荣先生最具体的配合，这个艺术计划将完全无法实现。在以往的工作过程中，我的好友，新传媒创办人孙冕、《新周刊》杂志主编封新城、电影导演张元都在精神上及具体工作上给予了我极大的支持。我想：人的幸运，除了命运的安排，得到真挚朋友的帮助是最大的幸运。我的欧洲老友，杰出的艺术馆馆长培尔·霍伍德拿克，在我十多年前刚到欧洲的工作、生活，包括回到中国后，一直给予我长辈似的关怀，让我坚信我所做的工作的重要性。同样，我的朋友，伟大的艺术家克里斯多夫、珍妮·克劳德夫妇对我的支持和鼓励，让我坚信艺术家应该这样的生活着。我要感谢我的活动策划人王墨，我还要感谢摄影师Jon Hauge，Morten Krogvold，Trond Brubak，冼伟强、谢至德、严志刚、张炳玲、Øystein Thorvaldsen，以及本书的翻译凯伦·史密斯小姐，还有我的助手深田几年来对我工作上的帮助。此外还要感谢香港艺倡画廊主持人金董建平女士，在我回到中国后，对我艺术上的热情支持。正因为有了这么多的朋友、同事的支持和鼓励，才让我能够完成此书中的工作。对此，我感到欣慰。最后，我要深深地感谢我的家人多年来对我选择走这样一条艺术道路一如既往的支持。**米丘**

2002年元月　于上海

In August 2000, Mr. Wang Yanbing, editor of The China Architecture & Building Press gave me a call, saying that the press was going to publish a book collecting my works. I told him frankly that several publishing houses had already made arrangements in advance with me for my contribution. I wondered why The China Architecture & Building Press wanted to publish a book of my works. Mr. Wang explained that this was solely because I had lived and worked in the Ministry of Construction for five years. And, he added, I would have the final say in everything from the compiling and publishing of the book to the time of publishing. I felt a surge of warmth at that moment, for they still remembered me fifteen years after I had left the Ministry of Construction. Afterwards, I learned that there were in fact many more of my former colleagues who had been paying close attention to my work all along. This was probably due to the fact that only those who were engaged in a trade like construction – that was both ancient and modern – could have had such a particular mentality and state of emotion. A couple of days after the call, I made an appointment with the editors of The Chinese Construction Industry Press and met them in Shanghai. Then I made up my mind to publish this book. So, I telephoned my friend Mrs. Shu Kewen main editor of "LIFE WEEK·SDX" to invite her to write a preface for this book, but she recommended her husband Professor Zhao Tingyang for this task instead. Zhao is also one of my good friends. I always enjoy chatting with him every time we meet on a tour or when we talk over the phone. Soon, at my invitation, my friend Chai Ning also took part in the revising and editing of the book. After going through my manuscripts and the related illustrations, designer Jiang Qinggong devoted himself with great enthusiasm to the art design work of this book. Several months later, I was finally gratified to see a perfect design presented before me. I left China in 1987 and did not return from abroad until 1996.

Nearly one decade of residing overseas as well as several years in the wake of my return have passed away in a flash. Though I am always ready to take the world as it is, this book records only part of my artistic involvement. Its making has become a truly significant part of my life journey and one of my most fond memories. Not long after I came back to China, my former classmate, architect Le Xing made an appointment with me and expressed his desire to cooperate with me. Our conversation warmly brought back memories of the familiar and unsophisticated campus life of more than ten years ago. I also met with my junior schoolmates Xu Liang, Huang Xiangming and Lu fen, who were outstanding among their fellow students in Tongji University. Thanks to my cooperation with them, I eventually completed the environmental artwork for China Life Insurance Ltd. and finished the environmental design for the Second Yearlong Contemporary Sculpture Exhibition for the He Xiangning Art Gallery. I'd like to give my thanks to the president Mr. Ren Kelei and vice president Mr. Chen Jian of Overseas Chinese Town and vice director Mrs. Le Zhengwei of He Xiangning Art Gallery. For the latter part of my work, designer Han Jiaying even made a point to create a perfect integral plane and publication design, which left a deep impression on the viewers. In recent years, photographers including Cheng Haiwen, Xiao Quan, and Lu Wenming have made unremitting efforts to record my work in an all-around manner and produced many exquisite photos. I am truly deeply touched by the perseverance in their work. How fortunate I am to be the recipient of so much concern and care in my work and my life! On the occasion of the forthcoming completion of "Wish-2000 Art Project" in Da MeiSha, Shenzhen city, I would like to give my thanks to my co-workers Mr. Dai Beifang and Mr. Lu Ruifeng whose holding office in Yantian district of Shenzhen city as well as those working in the Shenzhen Urban Planning and Land Administration Bureau

with Mr Xu Chongguang, Mr. Qiao Hengli and Mr Xu Rong (Yantian Branch). For without their considerate and generous support, the completion of this art project would have been entirely hopeless. In the past, my good friends such as Sun Mian, the founder of New Media, Feng Xingcheng, its chief editor of "NEW WEEKLY", and the movie director Zhang Yuan, have offered me great help, spiritually and technically. Therefore, I have come to believe that one truly may be predestined for their fortune, but his greatest fortune is the assistance of his close friends. My old friend Per Hovdenakk, the distinguished head of a well-known art center in Europe, has, throughout the many years, shown constant and mentor-like solicitude to me and convinced me of the importance of my work. Likewise, my friends Christo and Jeanne-Claude, two great artists that have continued to support and encourage me and convinced me of the meaningful way of life as an artist. I am grateful to Wang Mo, who has planned and coordinated my work on this book. I would like to express my gratitude to photographers like Jon Hauge, Morten Krogvold, Trond Brubak, Xian Weiqiang, Xie Zhide, Yan Zhigang, ZhangBingling, Øyesteln Thorvaldsen. To Karen Smith, for the translator of this book and to my assistant Liang Tian, who has offered me a significant helping hand in my work during the past few years. Furthermore, I am also indebted to Mrs. Alice King, a Hong Kong director from Alisan Fine Arts Ltd, who has given me warm-hearted support in all of my work. I should say, it is only through the assistance and encouragement of so many friends and colleagues that I have succeeded in completing my work on this book. I truly feel honoured to have worked with so many fine and outstanding people! Finally, I would like to give my heartfelt thanks to my family, who remain as always my number one supporter of my decision to dedicate myself to the field of art. Mi Qiu In January 2002, Shanghai

摄影	PHOTOGRAPHER
陈海汶	Chen haiwen
Jon Hauge	Jon Hauge
陆元敏	Lu yuanmin
Morten Krogvold	Morten Krogvold
Trond Brubak	Trond Brubak
肖全	Xiao quan
冼伟强	Xian weiqiang
谢至德	Xie zhide
严志刚	Yan zhigang
张炳玲	Zhang bingling
Øysteln Thorvaldsen	Øysteln Thorvaldsen

图书在版编目(CIP)数据

　米丘　观念＋环境的艺术／米丘著. —北京: 中国建筑工业出版社，2002
　（艺术家书系）
　ISBN 7-112-04890-7

　Ⅰ. 米… Ⅱ. 米… Ⅲ. 艺术—作品综合集—中国—现代　Ⅳ. J121

　中国版本图书馆CIP数据核字（2001）第081343号

策划: 王雁宾
设计: 姜庆共
完稿: 蔡文瑾
英文翻译: Karen Smith
英文校订: Mark Kitto　Dana R. Shymkowich
责任编辑: 王雁宾　杨虹

艺术家书系
米丘　观念＋环境的艺术

中国建筑工业出版社出版、发行（北京西郊百万庄）
新华书店经销
印刷: 深圳宝峰印刷有限公司
开本: 787 × 1092毫米　1/16开本
印张: $17\frac{3}{4}$
字数: 330千字
2002年1月第一版
2002年1月第一次印刷
印数: 1-3000册
定价: **160.00**元

ISBN 7-112-04890-7
　X·35(10369)